THE CHRISTIAN CELTS

Treasures of Late Celtic Wales

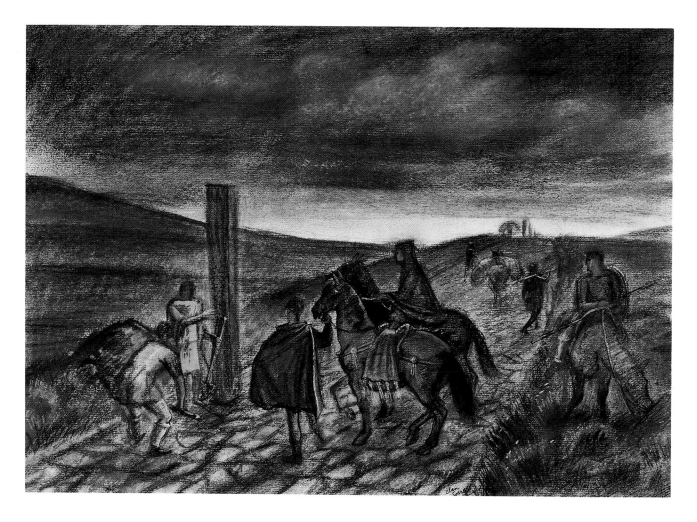

A reconstruction by Alan Sorrell of kinsmen setting up a memorial stone to Dervacus, the son of Justus, besides the Roman road from Coelbren to Brecon Gaer, known today as 'Maen Madog' ('The Stone of Madoc'; ECMW 73). This location continued the Roman practice of roadside burial. Excavations after its fall in 1940 found evidence for an earlier socket for a stone on the very edge of the buried road, some 5 metres away. From its position on a low ridge between the Upper Nedd and Afon Llia, it must have formed a prominent marker from below looking down on the valley in which Dervacus' farmstead may have lain. The inscription in debased Roman capitals reads: DERVACI FILIVS/IVSTI IC IACIT *('(The stone) of Dervacus, son of Justus. He lies here'). (By permission of Lady Fox)*

THE CHRISTIAN CELTS

Treasures of Late Celtic Wales

Mark Redknap

of the Department of Archaeology and Numismatics,
National Museum of Wales

AMGUEDDFA GENEDLAETHOL CYMRU
NATIONAL MUSEUM OF WALES
CARDIFF 1991

First published in May, 1991
© National Museum of Wales

Published by the National Museum of Wales
Cathays Park
Cardiff CF1 3NP

ISBN 0 7200 0354 7

Production: Hywel G. Rees
Design: ARB, Cardiff
Photography: Photographic Department, N.M.W.
Typesetting: Afal, Cardiff
Type: Baskerville 10/11 pt
Printing: South Western Printers, Caerphilly

Contents

Acknowledgements

The idea for this picture book owes much to Paul Williams, who assembled illustrations for the Early Christian Monuments, and revised an earlier guide to the stones by Donald Moore, published in *Anguedelfa*, the Bulletin of the National Museum of Wales (1972). Additional information has been derived from standard works on the period, in particular V.E. Nash-Williams, *The Early Christian Monuments of Wales* (1950); the *Inventory of the Ancient Monuments in Glamorgan Vol. 1: Pre-Norman. Part III The Early Christian Period* by the Royal Commission on Ancient and Historical Monuments in Wales; Wendy Davies's *Wales in the Early Middle Ages* (1982), and Jeremy Knight's *Sources for the Early History of Morgannwg* (1984) in the *Glamorgan County History*. I would like to thank in particular John Lewis, former Assistant Keeper of Medieval and Later Archaeology of the Department of Archaeology and Numismatics, and Gwyn Thomas, formerly of the Royal Commission on Ancient and Historical Monuments in Wales, Aberystwyth, who have both been engaged in a revision of the Nash-Williams corpus, and both kindly read and made comments on an earlier version of this book.

I am also very grateful to Jeremy Knight for many useful comments, and to George Boon, Richard Brewer, Dr Laurence Butler, Ewan Campbell, James Graham-Campbell, Dr Stephen Green, Terrence James and Dr Alan Lane for generously providing information, much in advance of publication. My warm thanks go to Edward Besly, Peter Humphreys, Heather and Terrence James, Chris Musson, John Tipton and Susan Youngs for photographs and information, Tony Daly for the line drawings, and to Yolanda Stanton Courtney, Monica Cox, Kate Hunter, John Kenyon, Sharon Moyle, Louise Mumford, Fiona Runnalls, Colin Williams and the photographic department of the National Museum of Wales for contributing to the production of this book.

Grateful acknowledgements are also due to the Ashmolean Museum, the Bodleian Library, the British Museum, Carmarthen Museum, Cadw: Welsh Historic Monuments, the Dean and Chapter of Lichfield Cathedral, the Department of the Environment (Northern Ireland), the Dyfed Archaeological Trust, Newport Borough Council and Newport Museum and Art Gallery, the Royal Commission on Ancient and Historical Monuments in Wales (RCAHMW), Trinity College Dublin, the University of Wales College of Cardiff and University College Oxford, for photographs and permission to reproduce them in this book.

Abbreviations

ECMW	V.E. Nash-Williams 'The Early Christian Monuments of Wales' (1950) (followed by catalogue number)
EMSW	Edwards, N. and Lane, A. (eds) 'Early Medieval Settlements in Wales A.D.400-1100' (1988)
Gal...(no.)	Number of stone in the Early Christian Monuments Gallery, National Museum of Wales
Gal.cast...(no.)	Number of cast in Early Christian Monuments Gallery, National Museum of Wales [e.g. Gal. cast 13]

Foreword

The popular images of Wales between the Roman occupation and the arrival of the Normans are of heroic warrior kingdoms and travelling saints, of Celtic revival and of a tradition of mythical history. This picture book is intended both to accompany the Early Christian collection of the National Museum of Wales, and to illustrate this formative phase of Welsh history through its surviving monuments and artefacts.

The period has been referred to by many terms, some accompanied by a confusion of definitions, such as the Dark Ages, the Early Medieval period, the Early Middle Ages, the Early Christian period, the Age of Saints, the Age of Arthur and the Later Celtic period. While recent surveys have usefully employed terms equivalent to those for Saxon England, such as 'Sub-Roman' (A.D.350-450), 'Early Christian' (A.D.450-650), 'Middle Phase' (A.D.650-850) and 'Cambro-Norse' (A.D.850-1066), the use of the term 'Early Christian' for the whole period in this book reflects its concentration on the Early Christian monuments of Wales and the profound effect of Christianity on its Society.

Over the last 40 years, considerable progress has been made in historical and archaeological research into the period, with studies of charters and with excavations at fortified sites such as Dinas Emrys (Gwynedd), Dinas Powys (South Glamorgan) and Llangorse crannog (Powys), and at Early Christian cemeteries such as Caer Bayvil (Dyfed), Caerwent (Gwent) and Capel Maelog (Powys). The inscribed stones of various kinds are the most numerous visible relics of the Christian Celts, and they form the backbone of this book. They span a period from the 5th to the 12th centuries, illustrate the Christianity and artistic styles of Wales and provide evidence of its early society.

This introduction is bound to be incomplete, but its purpose is to acquaint the reader with Early Christian Wales through the collections of the National Museum of Wales and other institutions.

Alistair Wilson
Director

Celts and Kingdoms

Until the end of the 4th century A.D. Wales was part of a Roman Empire united to a varying degree by language, law and a sophisticated system of government. From the 5th century a number of small independent tribal kingdoms or territories developed in Wales, with roots in Celtic Iron Age and Roman traditions.

The pattern of political development is complex, with few continuously dominant kingdoms and little sense of 'Celtic' unity. Some early kingdoms may have maintained a semblance of late Roman authority but the evidence for the 5th century is sparse. Latin terms are used to describe official positions as if to suggest the inheritance of Roman power (for example, St Patrick's father was a DECURIO) and some personal and place names derive from Roman antecedents. Gwent, for example, preserves the name of the *civitas* capital *Venta Silurum* (now Caerwent), where the post-Roman use of an extra-mural cemetery outside the East Gate suggests that it may have continued as the focus of a small successor state.

However, there was considerable political dislocation and change in the 5th and 6th centuries, and the precise circumstances of the decline and abandonment of late Roman sites are unclear. Irish raids and inter-regional hostilities resulted in the refortification of some hillforts. Gradually smaller territories were absorbed into the larger kingdoms. Dynastic change in Dyfed and

Gwynedd led eventually to political change. Following the death in A.D.854 of Cyngen, last king of Powys (named as patron in the inscription on the 'Pillar of Eliseg'), the kingdom was absorbed into the larger kingdom of Gwynedd. The growing ambition of Gwynedd in the late 9th century resulted in the southern Welsh kings seeking protection from the Saxon king Alfred of Wessex. Viking raids on the Welsh coast began in the mid 9th century, and the 10th century was characterised by dynastic instability. New ruling families established themselves in the south-east by c. A.D.950, and by the 11th century further intrusive dynasties had moved into the south-west of Wales. A long period of wide-ranging conflict between rulers ended with the arrival of the Normans and the development of new conflicts.

Christian communities existed in parts of Wales under the later Roman Empire. While there may still have been unconverted Britons in the 5th century, the history attributed to Nennius (*'Historia Brittonum'*) suggests that Christianity survived in some form into the Early Middle Ages. It is significant that the earliest carved stones with Christian associations are particularly numerous in Wales. The artistic, religious and political development of the Principality during this period is reflected in its Early Christian monuments and distinctive artefacts.

Map of Wales, showing location of main Early Christian kingdoms. Gwynedd, Dyfed, Powys and Gwent can be identified in the 6th century from Gildas and other sources. From the Llandaff charters further minor kingdoms in the south-east are identifiable in the late 6th century, and a new dynasty in the early 7th century. Other sources indicate the existence of Brycheiniog and Ceredigion in the 8th century. This may not be the total number of early kingdoms

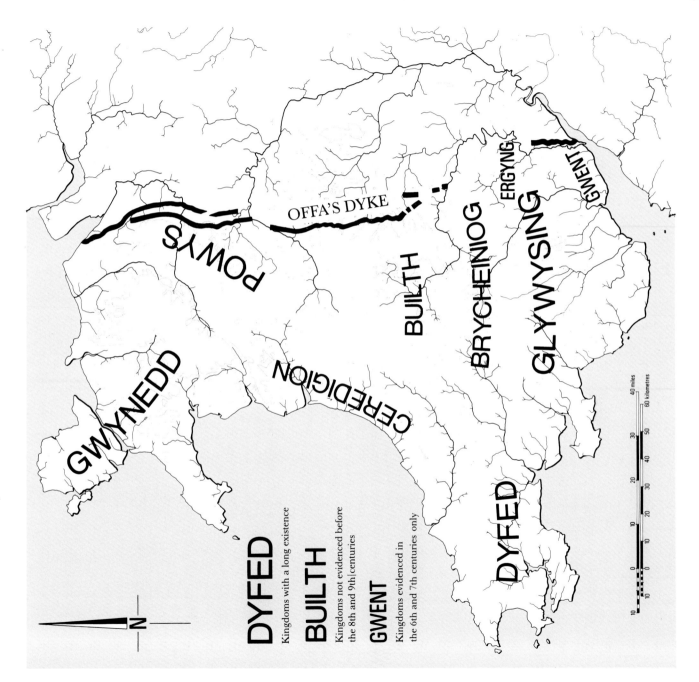

OFFA'S DYKE

GWYNEDD

POWYS

CEREDIGION

BUILTH

BRYCHEINIOG

ERGYNG

GLYWYSING

GWENT

DYFED

DYFED

DYFED
Kingdoms with a long existence

BUILTH
Kingdoms not evidenced before
the 8th and 9th centuries

GWENT
Kingdoms evidenced in
the 6th and 7th centuries only

N

10 0 10 20 30 40 miles

10 0 10 20 30 40 50 60 kilometres

The 'Pillar of Eliseg', Valle Crucis, Powys (ECMW 182). The cross was thrown down in the Civil War, and lay in two pieces when recorded by Edward Lhuyd in 1696. The original inscription, now worn and incomplete, was exceptionally long (at least 31 lines) and in translation reads:

+ Concenn son of Cattell, Cattell
son of Brohcmail, Brohcmail son
of Eliseg, Eliseg son of Guoillauc
+ Concenn therefore being great-grandson of Eliseg
erected this stone to his great-grandfather
Eliseg + It is Eliseg who annexed
the inheritance of Powys...
throughout nine (years:) from the power of the English,
which he made into a sword-land by fire
+ Whosoever shall read this hand-inscribed
stone, let him give a blessing on
the soul of Eliseg. + It is Concenn
who...with his hand
...to his own kingdom of Powys
...and which ...

...

the mountain ...

... the monarchy
Maximus...of Britain...
Concenn, Pascent,...Maun, Annan.
+ Britu, moreover, (was) the son of Guorthigirn (= Vortigern,),
whom Germanus blessed and
whom Severa bore to him, the daughter of Maximus
the King, who slew the king of the Romans.
+ Conmarch painted this
writing at the command of his king
Concenn
+ The blessing of the Lord (be) upon
Concenn and all members of his family
and upon all the land of Powys
until the Day of Judgement. Amen.

Concenn (died A.D.854) and Eliseg were kings of Powys. The pillar was a noted landmark before its destruction in the 17th century, and gave the name to the small valley and nearby Cistercian abbey of Valle Crucis ('Valley of the Cross'). Height of existing pillar 2.41 m overall. (Photograph: Crown Copyright. By permission of Cadw: Welsh Historic Monuments)

Settlement

'Aduwyn gaer yssyd yn yr eglan.
atuwyn y[t] rodir y pawb y ran.
Atwen yn dinbych gorwen gwylan.
kyweithyd wleidud ud erllyssan.'

'There is a fine fortress on the promontory.
Graciously each one there receives his share.
I know at Dinbych — pure white is the sea-gull —
The companions of Bleiddudd, lord of its court.'

(Etmic Dinbych, 'In praise of Tenby', 9th–10th century. Translated by the late Sir Ifor Williams)

crannog or artificial island in Llangorse Lake, Powys. One class of site believed to reflect settlement patterns is the cemetery, with graves orientated east-west in the Christian manner (for example, Caerwent, Caer Bayvil and Llantwit Major).

The identification of settlement sites is made difficult by a scarcity of diagnostic artefacts. Physical traces of settlement on the ground are hard to detect, and the continuous nature of occupation on certain sites prevents excavation.

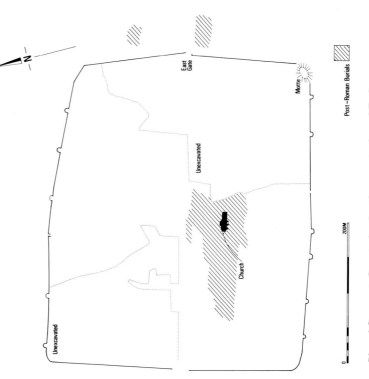

Plan of Caerwent, Gwent, showing the concentrations of Early Christian burials. Both were first discovered in the mid 19th century. Radiocarbon determinations give dates for graves from the 5th–10th centuries

I n the 5th century, large scale, sophisticated architecture and stone building that had characterised the period of Roman rule gave way to simpler forms of construction. During the 5th–7th centuries some settlements occupied strongly defended hilltops (for example, Dinas Powys, Degannwy), a practice noted by the writer Gildas in the 6th century. These acted as seats and prestige symbols of political power and reflect the warlike nature of post-Roman society. Some hilltop sites (for example, Dinas Emrys, Coygan and Dinorben) show evidence for late Roman activity, raising the question of their continuous use into the Early Christian period. Limited occupation occurred on the sites of former Roman towns or forts (for example, Caerwent, and possibly Segontium), but no evidence yet exists for the continued domestic occupation of former Roman villas (although the possibility of ecclesiastical use exists at Llantwit Major). Coastal cave sites in South Wales and some hut groups in north-west Wales show evidence of use, though few are certainly dated. Nucleated communities may have grown up around royal courts and religious settlements, but the bulk of the population probably lived in small, scattered communities.

Few sites belonging to the 9th and 10th centuries have been identified. Exceptions include the Anglo-Saxon borough (*burh*) of *Cledemutha* at Rhuddlan, founded by Edward the Elder in A.D.921. This was a 'plantation' settlement, an attempt to establish a large town of a type alien to native forms of settlement. A rare, possible royal, type of settlement at this period is the fortified

11

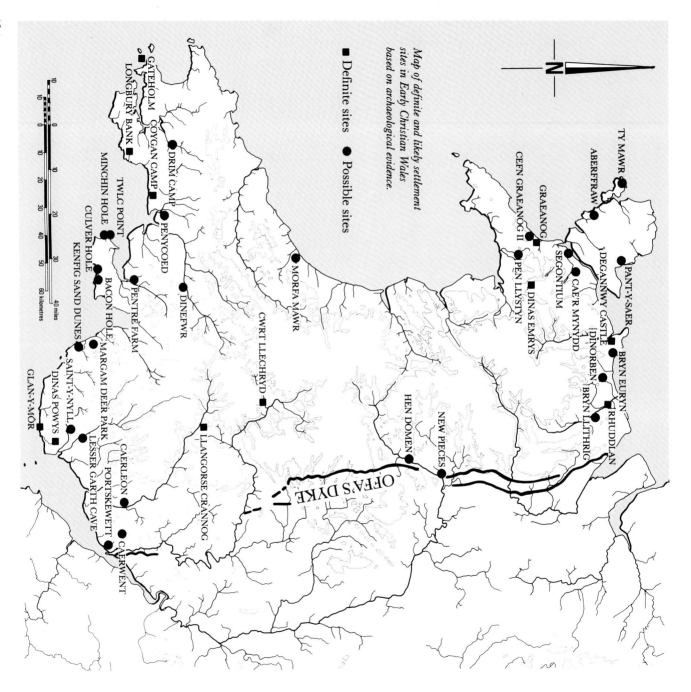

Map of definite and likely settlement
sites in Early Christian Wales
based on archaeological evidence.

■ Definite sites

● Possible sites

GATEHOLM
LONGBURY BANK
COYGAN CAMP
DRIM CAMP
PENYCOED
MINCHIN HOLE
TWLC POINT
CULVER HOLE
KENFIG SAND DUNES
BACON HOLE
PENTRE FARM
DINEFWR
MORFA MAWR
CWRT LLECHRYD
MARGAM DEER PARK
SAINT-Y-NYLL
DINAS POWYS
LESSER GARTH CAVE
GLAN-Y-MÔR
CAERLEON
PORTSKEWETT
CAERWENT
LLANGORSE CRANNOG
HEN DOMEN
NEW PIECES
OFFA'S DYKE
TY MAWR
ABERFFRAW
PANT-Y-SAER
DEGANNWY CASTLE
DINORBEN
BRYN EURYN
BRYN LLITHRIG
RHUDDLAN
CAE'R MYNYDD
SEGONTIUM
DINAS EMRYS
PEN LLYSTYN
GRAEANOG
CEFN GRAEANOG II

10
0 10 20 30 40 50 60 kilometres
0 10 20 30 40 miles

N

The Royal Residences at Dinas Powys and Llangorse

DINAS-POWYS, PRINCELY FORT IN THE SOUTH

The village of Dinas Powys, situated four miles south-west of Cardiff, is now a small settlement whose documentary history begins in the 12th century. Few people are aware of its much older history on a whale-back hill of Carboniferous limestone half a mile north-west of the medieval castle.

Excavations by Mr (now Professor) Leslie Alcock of University College, Cardiff between 1954 and 1958 recorded six phases of activity on this hill-top. The earliest activity was Iron Age, indicated by a scatter of pottery over the site. The construction of the defended enclosure is likely to have taken place in the late 5th century A.D., with occupation at least during the 6th and 7th centuries A.D. One can still see today four roughly concentric banks and ditches which cut across the neck of the limestone promontory to enclose an area of about 0.1 hectares (1,000 square metres). The sequence of construction is complex. The earliest rampart (Bank 2) appeared to be of simple dump construction, while the second and subsequent ramparts to be constructed (Banks 1, 3 and 4) had outer stone revetments. A palisade or fence probably stood on top of the bank around the enclosure within the earthworks.

Within the enclosure no foundations for walls were found, but two buildings were identified by the gullies dug to carry away the rain water from the roofs. The larger appears to have been preceded by a timber post-built structure. At least three stone-lined industrial hearths, in addition to small bowl hearths, were discovered.

Pottery imported to the site between 5th and 7th centuries includes fine red slipwares and *amphorae* for wine from North Africa and the eastern Mediterranean, table-ware grey bowls (known as 'D ware' or *sigillée paléochrétienne grise*) probably from the Bordeaux region of France, and coarse, beige coloured kitchen-ware jars (known as 'E ware') from north-western France. Fragments of glass cone beakers and bowls, with two claw beakers and a squat jar, as well as metalware of Anglo-Saxon type, were also found. Metal smithing and

bronze casting were indicated by the presence of hearths, and the discovery of lidded crucibles containing residues of bronze and gold, a fragmentary lead die or model for making moulds for a zoomorphic penannular brooch of Irish type, glass and *millefiori* rods for decorating casts, and a few mould fragments.

The scale of the Dinas Powys settlement is small, but the occupational debris from the site suggests that the inhabitants had a privileged lifestyle. Given the quantity of imported objects and the range of debris from metalworking and jewellery manufacture, it is likely that the small fortification represents the defended settlement of a noble person, if not the *llys* (court) of a Welsh lord.

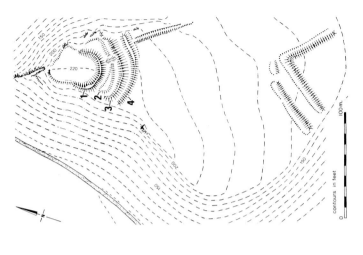

Plan of the earthworks at Dinas Powys, South Glamorgan

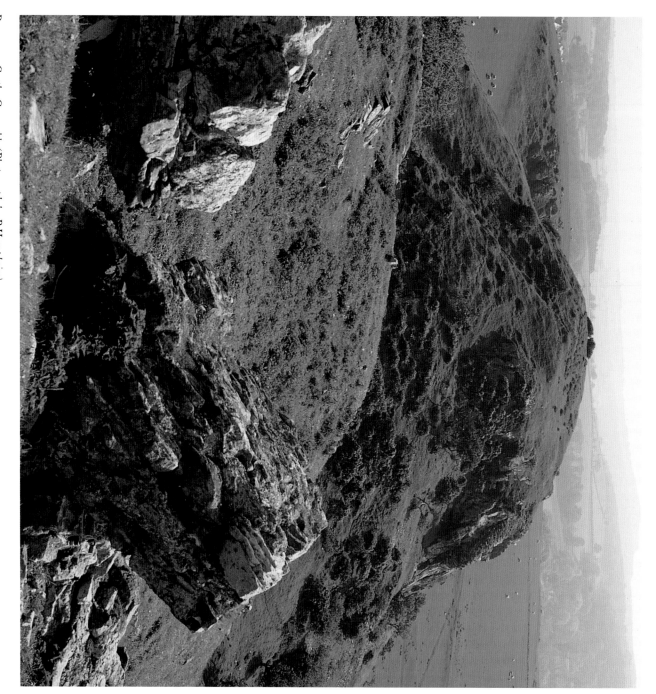

Deganwey Castle, Gwynedd. (Photograph by P. Humphries)

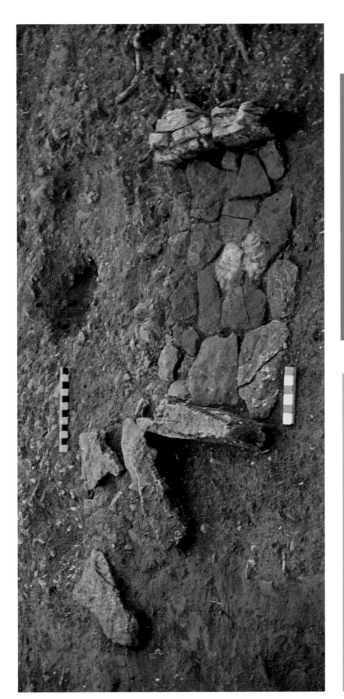

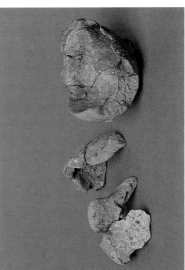

Crucible fragments from Dinas Powys. A wide range of shapes has been recognized on Early Christian industrial sites, derived from Iron Age or Roman examples. (above)

Castle Hill, Tenby, Dyfed, from the south. (Photograph by J. Tipton) (left)

Hearth D lined with sandstone slabs from beneath Bank 1, Dinas Powys, South Glamorgan. (Photograph by permission of University of Wales College of Cardiff) (top)

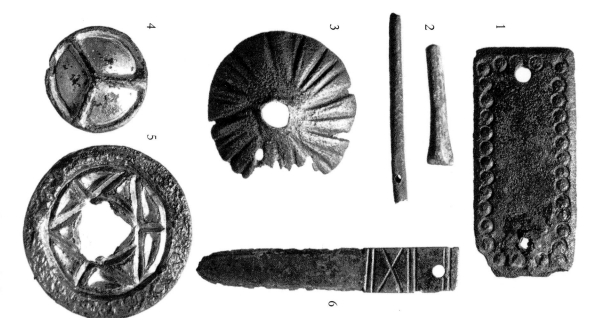

'Germanic' ornamental metalwork from Dinas Powys. 1 = Anglo-Saxon belt mount; 2 = lace-tags of Anglo-Saxon type; 3-5 = Anglo-Saxon shield fittings. The gilt chip-carved disc (5) is a shield boss ornament, torn from its fixture (diameter 23 mm); the gilt stud (4) was probably a shield fitting to hold a carrying strap (diameter 9 mm); 6 = strap-end of Kentish (Anglo-Saxon) type. (Acc.no. 62.203)

LLANGORSE CRANNOG — THE FORTIFIED ISLAND ON THE LAKE

In a hollow between the rivers Usk and Wye, overlooked by the Old Red Sandstone scarps of the Brecon Beacons and Black Mountains, lies Llangorse lake. At 160 hectares (1,600,000 square metres) it is the largest natural body of fresh water in South Wales, though at its deepest it is only seven metres in depth. Llangorse crannog is situated 40 metres from the northern shore of the lake, to the south of the present village of Llangorse. This artificial island measures today 40 metres across, and is covered by trees and by reeds. Completely man-made, little is visible today of the buildings that formerly occupied its area, which may have periodically housed the *llys* (court) of the king of Brycheiniog.

Wells, springs, lakes and rivers were sacred to the pagan Celts, who considered such natural phenomena capable of heralding future events. Llangorse lake was still renowned later in the 12th century for its prophetic powers. Gerald of Wales (*Giraldus Cambrensis*) noted not only the wealth of fish in the lake, but also its occasional green and red coloured currents, now believed to be algal blooms, but once thought to be a presage of invasion. He further recorded that those who lived there sometimes observed it to be completely covered with buildings, rich pasture lands, or adorned with gardens or orchards ('The Journey through Wales', *Itinerarium Cambriae*'). A 16th century manuscript refers to locals seeing 'sometyme, greate peeces of tymber and fframes of houses ffleeting upon the water' ('The Wonders of Wales', 'De Mirabilibus Cambriae'). There now seems little doubt that some of these early findings and sightings of sunken features, though embellished with time, relate to the vestiges of timber planks of the crannog palisade, once more prominent than today.

The crannog was observed in the late 1860s by two local antiquaries, Edgar and Henry Dumbleton, after the lake level had been lowered. In the publication of their observations they described a substantial mound of boulders lying on top of brushwood, reeds and lenses of sand. They noted that the south and west sides of the mound were edged by one or two oak palisades, but no conclusive evidence was produced to determine its date and scholars remained circumspect about the site. Then, in 1987, the examination of the site by a team from the University of Wales College of Cardiff

established the continued survival of timber on the south and east sides of the island. Dendrochronological dating of one sample gave a tree-ring sequence of A.D.747–859, indicating construction activity in the late 9th or early 10th centuries A.D.

In 1989 and 1990 the National Museum of Wales and the University jointly conducted programmes of survey and excavation both above and below water on the crannog. This established that the island had been periodically extended from an initial platform nucleus constructed of sandstone on brushwood, branches and timber, and that the crescentic extensions of vertical oak plank lines were accompanied by settings of vertical piles, with post-and-wattle retaining revetments on the inside. The incorporation of timber from earlier structures has provided archaeologists with the first tantalising evidence for Dark Age methods of wood-working and building in timber. Wooden buildings are referred to more often than stone in literary sources. For example, the 'Life of St Cadog' records that monks went to fetch new timber for their monastery, and that the timber roofs of the monastery at Llancarfan (South Glamorgan) were visible from a distance. While the Welsh laws, written down between c. A.D. 1200 and c. A.D. 1500, record details about housing, such as the nine houses that bondmen were to erect and repair for the king, it is unclear to what extent these details reflect earlier practice. The reused planks and beams from the crannog have shed light on the nature of such timbers and their joints and fastenings. No occupational horizons or house plans have been discovered within the palisade due to erosion and the limited scale of archaeological investigation so far.

Who then was responsible for constructing the crannog? We know from historical sources of a royal presence in the vicinity of Llangorse. The Llandaff charters include a reference, ostensibly of 8th century date, claiming that king Awst of Brycheiniog and his sons gave Llan Cors and its *territorium* to Bishop Euddogwy. The bounds, written in Welsh, are likely in their current form to date before the 10th century, but they indicate a royal estate of over 1000 hectares in the area, and one may presume a residence also. The Awst charter records the donation by Awst of his own and his sons' bodies to the church for burial. If true, this implies that the church could have been a royal burial

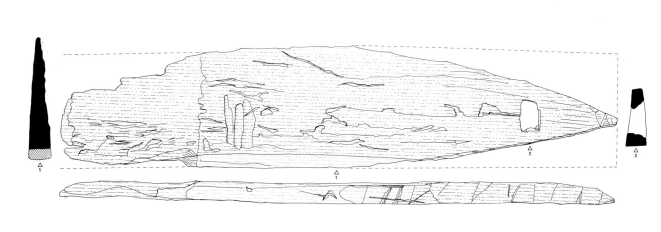

Oak plank with mortice from a wooden structure, reused in the 9th century palisade. Length 1.385 m.

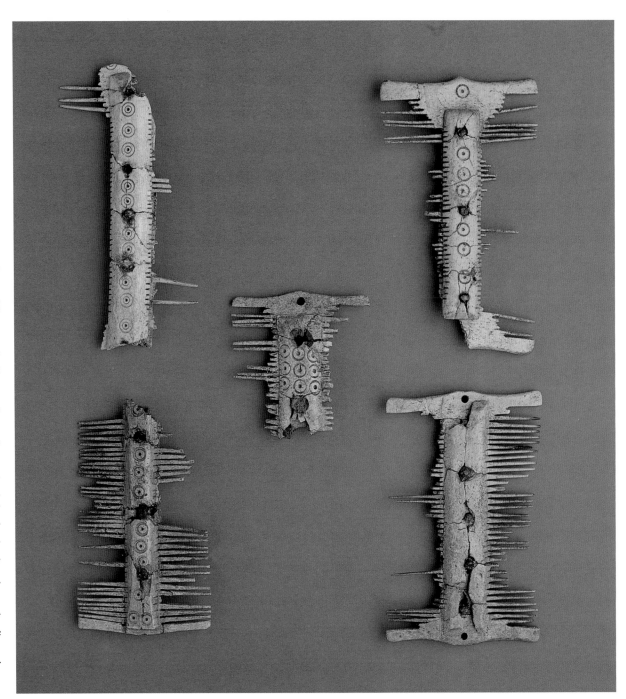

18

Bone combs of double-sided composite type from Dinas Powys. They were for disentangling and arranging hair, cleaning it and removing lice and fleas. Iron rivets pass through the side-plates to bind the teeth-plates together. There is some variation in the shapes of the end-plates, and decoration is confined to simple single or double ring-and-dot motifs. (Acc. no. 62.203)

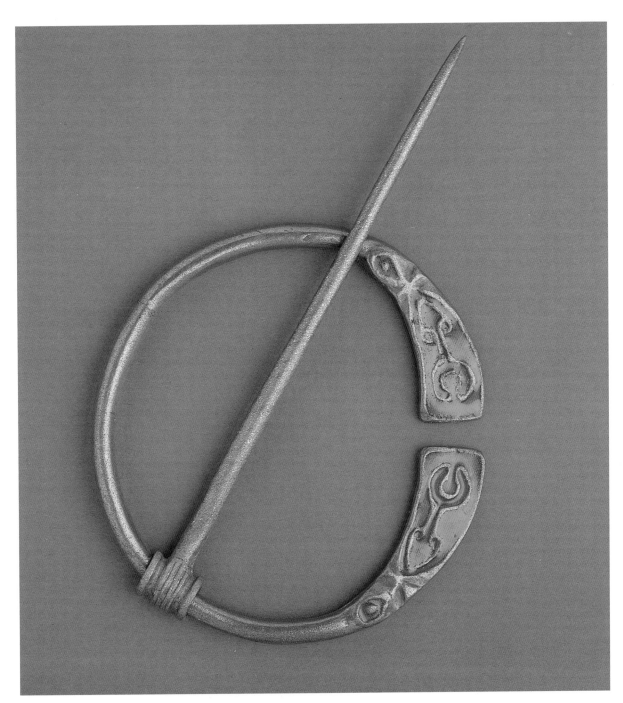

Reconstruction of an enamelled zoomorphic penannular brooch, based on the lead model of a terminal from Dinas Powys, South Glamorgan. No evidence was found for the form of pin, which is based here on Irish parallels. External ring diameter 7.6 cm. 6th–7th century A.D. (modelled by L. Mumford)

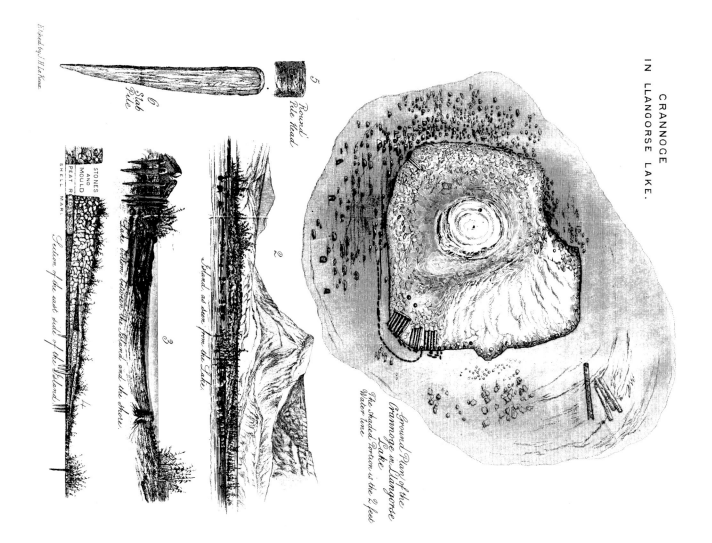

CRANNOGE IN LLANGORSE LAKE.

5 Round Pile Head.

6 Slab Pile.

Etched by J H Le Keux.

2 Island as seen from the Lake.

3 Lake bottom between the Island and the shore.

STONES AND MOULD
PEAT REDDISH
SHELL MARL

Section of the east side of the Island.

Ground Plan of the Crannoge in Llangorse Lake.
The shaded Portion is the 2 feet Water line.

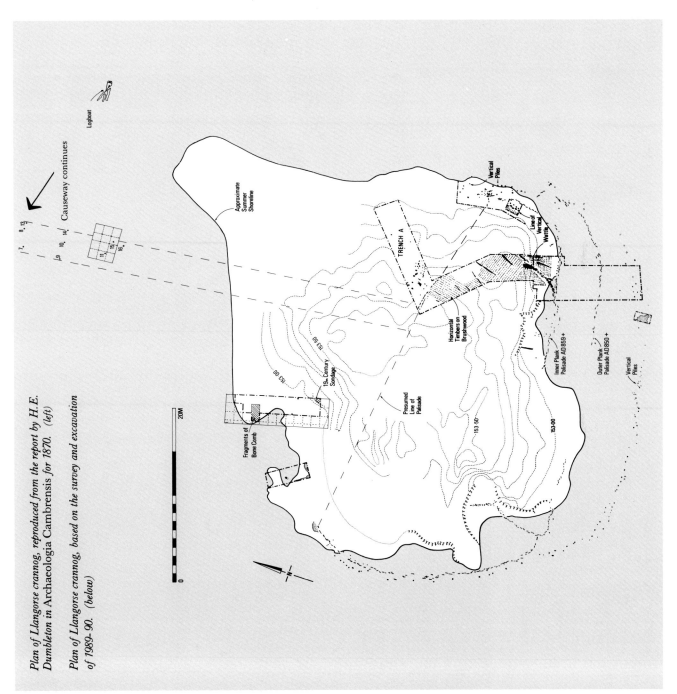

Plan of Llangorse crannog, reproduced from the report by H.E. Dumbleton in Archaeologia Cambrensis for 1870. (left)

Plan of Llangorse crannog, based on the survey and excavation of 1989-90. (below)

Logboat

Causeway continues

7.
8. 13.
9.
10.
11.
15.
16.

20M

0

Approximate Summer Shoreline

TRENCH A

153.50

153.00

19th-Century Sondage

Fragments of Bone Comb

Presumed Line of Palisade

153.50

153.00

Horizontal Timbers on Brushwood

Line of Vertical Wattle

Vertical Piles

Inner Plank Palisade AD 859+

Outer Plank Palisade AD 850+

Vertical Piles

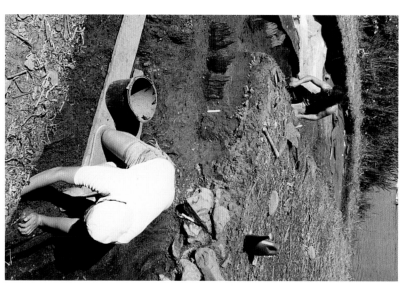

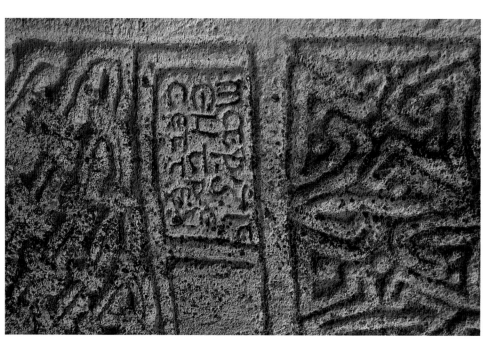

Excavation in progress at Llangorse crannog in 1989. In the foreground the oak palisade planks of the northern line; in the background 'extra-mural' silts and midden material. (top left)

Inscription from the Carew Cross commemorating Maredudd ap Edwin, descendant of Hywel Dda, who became king of Deheubarth in A.D.1033. It reads MARGIT/EUT:RE/X.ETG(un), FILIUS, '(The cross of) Margiteut, son of Eiguin (i.e. Edwin)'. The cross in likely to have been erected after his death in A.D.1035. (ECMW 303; Gal.cast 29) (Photograph by P. Humphries) (above)

Glass from Dinas Powys, of a type found in Anglo-Saxon graves. (Acc.no.62.203) (left)

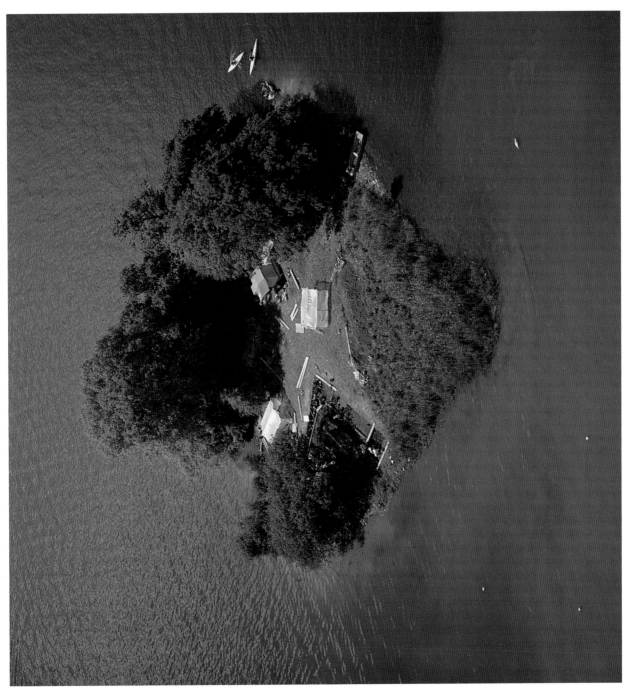

Aerial view of Llangorse crannog, Powys. (Crown copyright. (By permission the of Royal Commission on Ancient and Historical Monuments in Wales)

site; certainly the *monasterium* at Llan Cors later became the location for the settlement of a dispute in *c.* A.D. 925 between king Tewdwr and Bishop Libiau over food rent. The most obvious clue to a Dark Age presence at the village church are the fragments of Early Christian monuments housed in the nave.

Many crannogs are known in Ireland, and are similar to Llangorse in plan and construction. They are frequently rich in finds, and seem to be settlements of individuals or families of moderate to high rank.

During the excavations of the 1880s, bone, charcoal and a few fragments of leather, pottery and metal were found, but none survives for re-examination. The excavations in 1989 and 1990 have recovered evidence indicating a mixed economy of animal husbandry and cereal cultivation. Metalworking is suggested by small fragments of fired clay from furnace linings or hearths, and slag. A single-sided composite bone comb typical for the period was found, but the most exciting evidence for everyday life is provided by rare fragments of textile

found in silts outside the plank palisade on the north of the island.

Could Llangorse be a royal crannog like Lagore in Ireland? Manuscript B of the Anglo-Saxon Chronicle tells that shortly before midsummer A.D.916, Aethelflaed sent an army into Wales and destroyed *Brecenanmere* and captured the king's wife and 33 other persons. Brecenanmere, or Brecknockmere, was the old English name for the lake (Llyn Syfaddan in modern Welsh) until the 18th century. The Chronicle mentions an attack on the Mere itself, and this probably refers to the crannog. Consequently it was here that the queen, presumably the wife of Tewdwr ap Elised, the local king of Brycheiniog, was captured. That Llangorse was home of one of the leading families of 9th and 10th century Wales is supported by the fine, high quality textile, and carefully planned pattern of construction of the site, which required an ability to call upon a high level of specialised knowledge and resources.

Detail of cloth from Llangorse crannog, with a pattern that appears to be worked in a form of soumak (weft-wrap weave) brocading, or embroidery imitating it

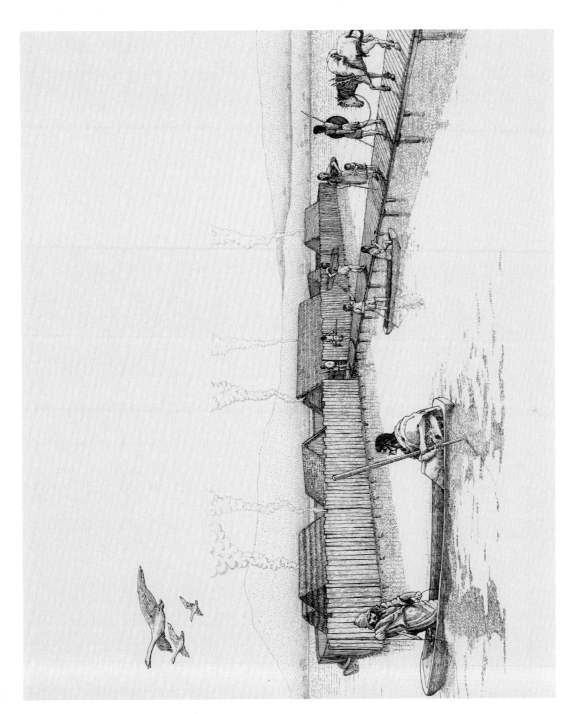

Reconstruction of the crannog, looking from the north. It was originally connected to the shore by a causeway which may have measured about 100 metres in length. (Drawing by T. Daly)

Kings, Warriors and Heroes

Society in Early Medieval Wales was hierarchial and divided by birth, land and office. Kingship was hereditary. Long lists of genealogies of royal ancestors traced a king's lineage (kinship) through famous rulers and often back to mythical origins. The king of a territorial unit (*rex, brenin*) ruled moving from place to place on horse with his court (*llys*), taking food and taxes, and giving gifts, land and privileges. Rulers were defined in relation to territorial names that mostly still exist — for example, Gwent, Gwynedd, Glywysing, Powys — and gave names to the people. Sometimes the areas were named after individuals, such as Brycheiniog from the personal name Brychan. A number of Welsh stones commemorate and name kings — notably Hywel ap Rhys (at Llantwit Major, South Glamorgan: ECMW 220); Vortipor (at Castell Dwyran, Dyfed: ECMW 138); Cadfan (at Langadwaladr, Gwynedd: ECMW 13).

Law and order were maintained by the king's warrior aristocracy through customary rule and procedures. Followers would form part of a ruler's household, though the relationship with the ruler was not necessarily lifelong. Nobility depended on birth and family, occupation, rather than wealth. The middle rank of society included craftsmen and traders, and the lowest the tenant peasantry and slaves. The church was not part of this social hierarchy, though there were grades of clergy, as on the Continent.

The heroic ethic recorded in poetry required gift giving of gold, weapons and land to secure friendship, revenues and services. 'Deserving one's mead' is a frequent theme. Its most famous articulation is the heroic poem *Y Gododdin*, one of the earliest known examples of literature in the Welsh tongue, which celebrates the unsuccessful expedition of a warrior-band to Catraeth (probably Catterick in Yorkshire) in the 6th century.

'Gwŷr a aeth Gatraeth yng nghad, yng ngawr,
Nerth meirch a gwrmseirch ac ysgwydawr,
Peleidr ar gychwyn a llym waywawr,
A llurugau claer a chleddyfawr.'

(*Y Gododdin*)

'Men went to Catraeth with battle-rank and warcry,
Power of horses, blue armour and shields,
Shafts held on high, and spearheads,
And shining coats of mail, and swords.'

(from the *Gododdin*, late 6th century; translated by Tony Conran)

By the 8th century, typical aristocratic gifts included weapons, horses, costly clothing, hunting gear, hawks, and hounds for the chase, as depicted on the base of the 'Conbelin' stone from Margam. Horses were important in Celtic society, and Welsh horses were highly valued, 150 forming in A.D. 1029 part of a ransom for the return of Olaf, the king of Dublin's son. The base of the stone at Llandough, South Glamorgan, depicts a mounted warrior. Welsh stud farms were renowned by the late 12th century, according to Gerald of Wales.

Few weapons survive. The sword was a highly valued, prestigious item, a gift worthy of high rank. King Mouric ap Teudiric granted *Reatir* (Roath, Cardiff) to Gourcinnim for a sword with a gilded hilt valued at 25 cows, while the gilded sword *Hipclaur*, worth 70 cows was given to cleric Conmogoy by Guengarth 'for the good of his soul' ('Life of St Cadog', *Vita Cadoci*). Sword blades at this time were occasionally incised or inlaid with the name of the blacksmith or owner. By the time Gerald of Wales wrote his 'Description of Wales', *c.* A.D.1193-4, the use of light weapons — arrows, long spears and round shields — in warbands led by warriors on horseback, was customary.

Very few images of lords or warriors survive. One of the best depictions in stone is of a bearded man clad in a tunic without girdle, with a short sword or *seax* in one hand and a club or mace in the other, on the Early Christian monument from Llandyfaelog Fach, Powys (ECMW 49). No Celtic swords from the early period in Wales have been found, but they may have resembled the parallel-sided slashing and thrusting sword used in Ireland. The growth of trade and of far-ranging warfare beyond territorial boundaries, against the Vikings and Mercians, ensured the spread of effective weapon design, and it is not surprising that a 9th century Anglo-Saxon sword with Trewhiddle-style decoration has been found in Powys.

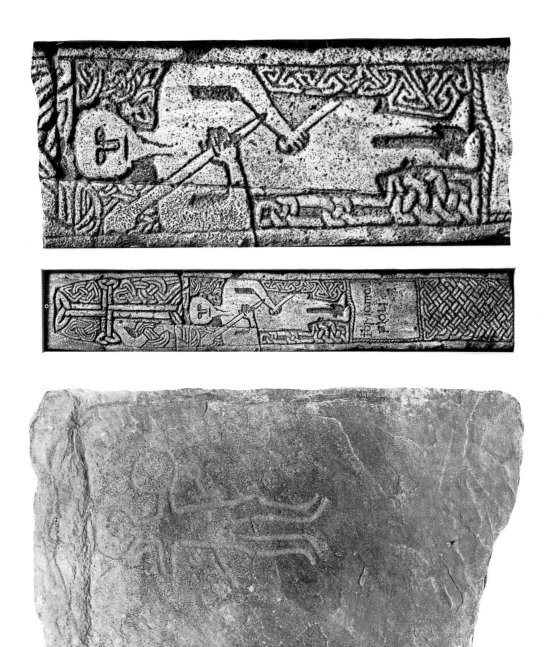

Incised figure of a warrior, on the sandstone slab from Eglwysilan, Mid Glamorgan (ECMW 195). His left hand holds a buckler (small shield) and slung at the waist is a long, straight-bladed sword with pommel and quillons. Height: 0.68 m. 8th–10th century A.D. (top)

Depiction of a warrior on the stone from Llandyfaelog Fach, Powys. The half-uncial inscription reads +BRIAMAIL FLOU, meaning 'The cross of Briamail Flou', probably the important figure illustrated. 10th-century A.D. (ECMW 49; Gal. cast 36)

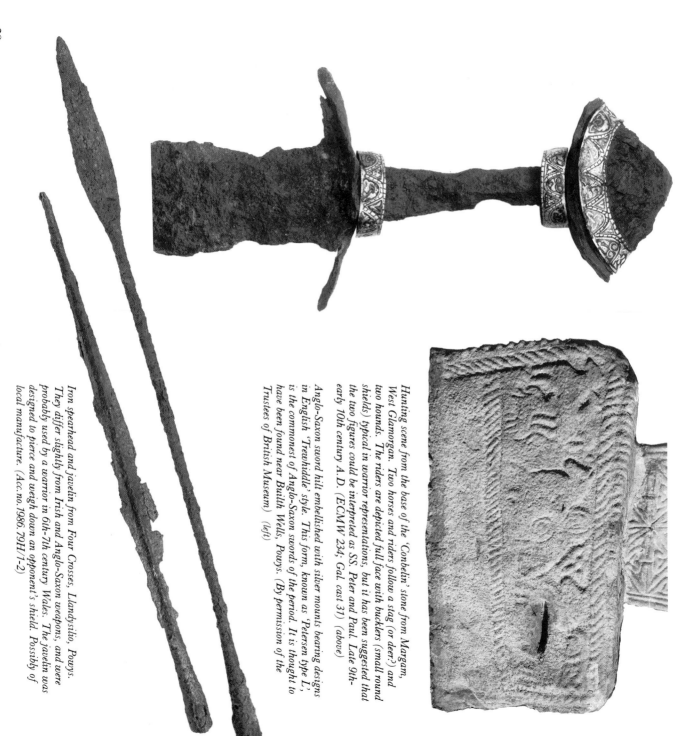

Hunting scene from the base of the 'Conbelin' stone from Margam, West Glamorgan. Two horses and riders follow a stag (or deer?) and two hounds. The riders are depicted full face with bucklers (small round shields) typical in warrior representations, but it has been suggested that the two figures could be interpreted as SS. Peter and Paul. Late 9th-early 10th century A.D. (ECMW 234; Gal. cast 31) (above)

Anglo-Saxon sword hilt embellished with silver mounts bearing designs in English 'Trewhiddle' style. This form, known as 'Petersen type L', is the commonest of Anglo-Saxon swords of the period. It is thought to have been found near Builth Wells, Powys. (By permission of the Trustees of British Museum) (left)

Iron spearhead and javelin from Four Crosses, Llandysilio, Powys. They differ slightly from Irish and Anglo-Saxon weapons, and were probably used by a warrior in 6th-7th century Wales. The javelin was designed to pierce and weigh down an opponent's shield. Possibly of local manufacture. (Acc.no.1986.79H./1-2)

Later Celtic Crafts

During this period the techniques and curvilinear decorative forms of the Late Iron Age were developed under the influence of Germanic (Anglo-Saxon) and Irish styles and ideas. Consequently it is often difficult to establish whether some art objects were made in Wales, Ireland or northern Britain. The resulting fusion of styles in Celtic Britain is sometimes called *Insular*.

What little metalwork survives from Wales reflects the existence of powerful and wealthy patrons. As with the earlier Celtic art, metalworkers combined a range of techniques: cast and punched decoration, tinning — to give the appearance of silver, and the use of glass rods (*millefiori*) and enamel to produce colourful designs. Much of the surviving metalwork from Wales is in the form of personal adornment, such as open-ring (penannular) brooches and stick or ringed pins used as cloak-fasteners. Dependant on fashion, bronzesmiths probably melted down much old jewellery as scrap for recasting according to current taste.

Form and decoration provide the main basis for dating the early metalwork. In the 5th century the style was derived from patterns of Celtic Iron Age origin which could be seen on metalwork in the Roman period. Workshop debris has shown that a variety of penannular brooches were produced in the 6th-7th century and later in Wales, Ireland and Pictish Scotland. Finds of raw materials, such as glass rods used in the manufacture of *millefiori* enamel, as at Dinas Powys, show that the capabilities for manufacturing objects decorated in this way existed in Wales. Skilled craftsmen in bronze, silver and gold would have found a ready demand for their skills in the middle- to high-ranking households of Wales. Little is known about jewellery manufacture in Wales between the 8th and 11th centuries. It is likely that ornament gradually developed in complexity, influenced strongly by Irish and Anglo-Saxon art. Metalwork in Ireland drew on indigenous patterns and from the 9th century on Hiberno-Norse (Viking) designs. Such products, dating to the later period, and decorated in Scandinavian style, have been found in Wales, having reached there either through trade, immigration or accidental loss.

The blacksmith was important to all Welsh communities. Swords were highly prized. Iron and tin were recorded on lists of precious metals, and a smith acted as a witness to one of the earliest Llandaff charters. Iron working was illustrated at Dinas Powys by the discovery of iron ore, fragments of furnace lining, fine ash slag and smithing debris. Iron tools found at the site appear to have been for iron, wood and leather working. The perishable nature of many objects has resulted in the poor survival of evidence for many important crafts such as wood and leather workers. However, waterlogged and anaerobic conditions of burial can result in preservation of organic materials such as leather and cloth, wooden bowls, buckets and tool handles. Some evidence for textile manufacture at Dinas Powys comes from the discovery of spindle whorls, linen smoothers and loom weights. Fragments of textile apparently of 9th- or 10th-century date have recently been recovered from the excavations at Llangorse crannog. Literary sources refer to cushions, pillows and linen cloth to serve as seats, quilts, cloaks and purple clothing. Costly clothes might even be exchanged in payment for goods. The types of metalwork differ from Anglo-Saxon jewellery and indicate a different style of dress and social conventions. Penannular brooches would have been worn singly by men and women, either on the breast or shoulder, with the pin pointing upwards.

Bone was used in the manufacture of many household items. Combs were made from red deer antler or bone. Long side-plates would be rivetted through a series of rectangular plates, which would have teeth cut into them. Earlier combs appear to be double-sided and short, whereas later examples are generally single-sided, and have longer side-plates. Several later Welsh examples are held together by bone pegs rather than iron rivets.

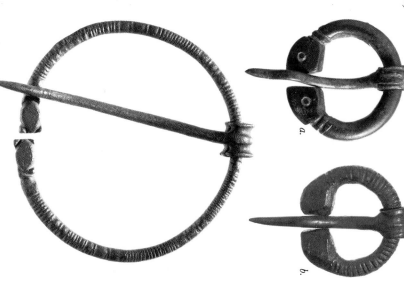

a. Small copper-alloy penannular brooch known as Fowler 'Type G', from Tiale Point, Llangynnydd, Gower, West Glamorgan. The general group includes several varieties current in different areas at varying periods between the 4th and 9th centuries. It has been argued that the form developed in a later Roman milieu. A larger example was found at Castell Collen Roman fort, Powys, arguably from a late Roman context (though possibly later). The early type appears to predominate in Wales and the West Country. Pin length 2.7 cm. 4th-6th century A.D. Ring diameter 1.9 cm. (Acc.no. 36.175) (below left)

b. Small copper-alloy 'Type G' penannular brooch with ribbed hoop from the Eastgate cemetery site, Caerwent, Gwent. The terminals are plain. External ring diameter 1.9 cm. 5th-6th century A.D. (below right)

Zoomorphic penannular brooch from Porth Dafarch, Anglesey, Gwynedd. The small terminals are derived from simplified animal heads. This type of brooch has been found in Wales, the west of England, North Britain and Ireland. An example of British metalwork. Diameter 6.9 cm. 5th-6th century A.D. (By permission of the Trustees of the British Museum)

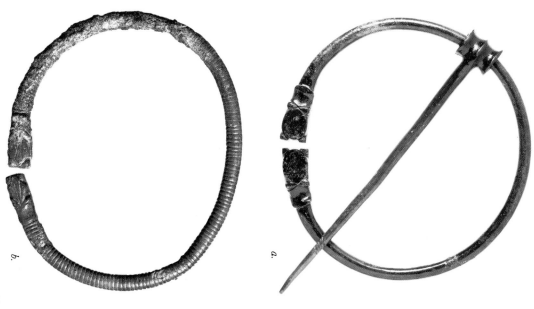

a. Early zoomorphic penannular brooch from Caerwent, Gwent. This type of brooch evolved from precursors of Roman date with animal-headed terminals, and was ancestral to the highly decorated penannular brooches of the 6th-7th centuries. 4th-5th century A.D. (By permission of Newport Borough Council and Newport Museum and Art Gallery) (top right)

b. Early zoomorphic penannular brooch from Segontium, Gwynedd. 4th-5th century A.D. (Acc.no. 23.292) (bottom right)

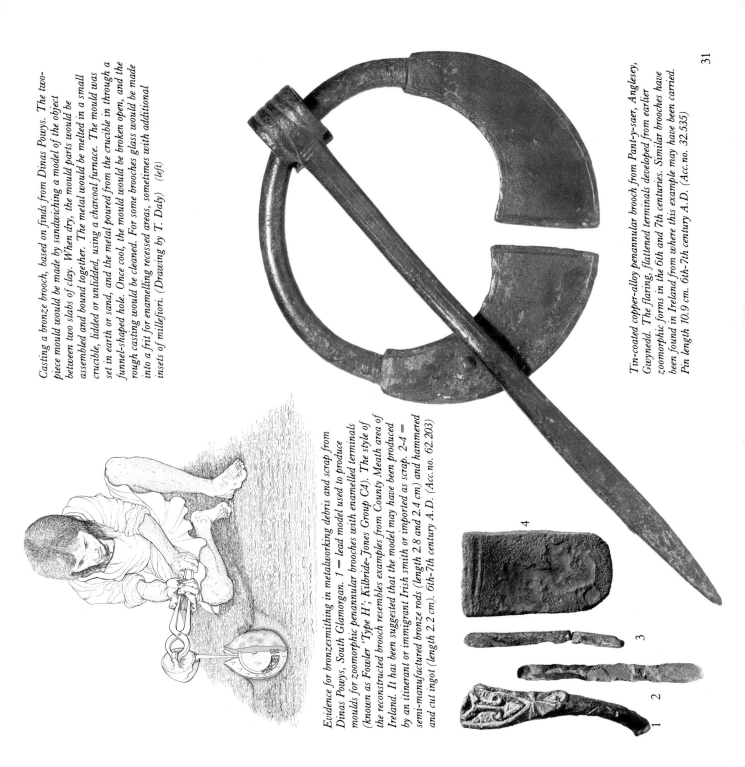

Casting a bronze brooch, based on finds from Dinas Powys. The two-piece mould would be made by sandwiching a model of the object between two slabs of clay. When dry, the mould parts would be assembled and bound together. The metal would be melted in a small crucible, lidded or unlidded, using a charcoal furnace. The mould was set in earth or sand, and the metal poured from the crucible in through a funnel-shaped hole. Once cool, the mould would be broken open, and the rough casting would be cleaned. For some brooches glass would be made into a frit for enamelling recessed areas, sometimes with additional insets of millefiori. (Drawing by T. Daly) (left)

Tin-coated copper-alloy penannular brooch from Pant-y-saer, Anglesey, Gwynedd. The flaring, flattened terminals developed from earlier zoomorphic forms in the 6th and 7th centuries. Similar brooches have been found in Ireland from where this example may have been carried. Pin length 10.9 cm. 6th-7th century A.D. (Acc.no. 32.535)

Evidence for bronzesmithing in metalworking debris and scrap from Dinas Powys, South Glamorgan. 1 = lead model used to produce moulds for zoomorphic penannular brooches with enamelled terminals (known as Fowler 'Type H'; Kilbride-Jones Group C4). The style of the reconstructed brooch resembles examples from County Meath area of Ireland. It has been suggested that the model may have been produced by an itinerant or immigrant Irish smith or imported as scrap. 2-4 = semi-manufactured bronze rods (length 2.8 and 2.4 cm) and hammered and cut ingot (length 2.2 cm). 6th-7th century A.D. (Acc.no. 62.203)

31

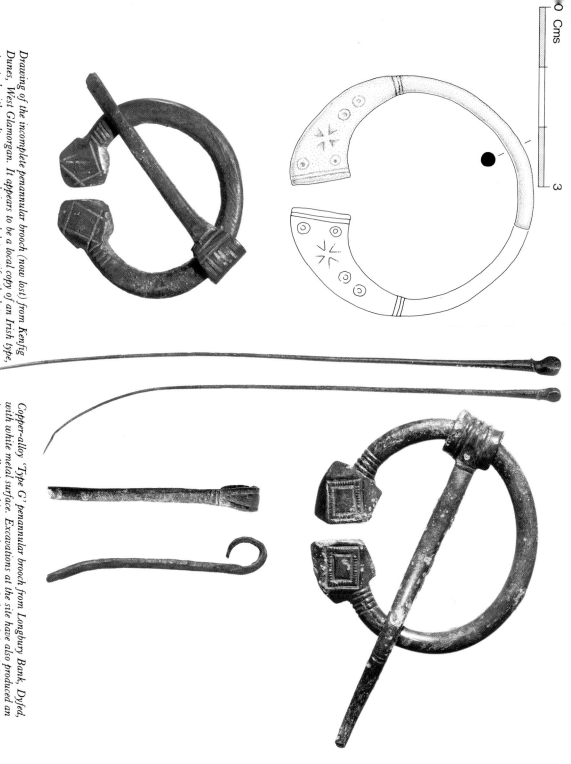

32

Drawing of the incomplete penannular brooch (now lost) from Kenfig Dunes, West Glamorgan. It appears to be a local copy of an Irish type, stamped with maltese cross and ring and dot motifs, the latter appearing commonly on small objects of British origin. 6th-7th century A.D. (top)

Copper-alloy penannular brooch from Linney Burrows, Dyfed. Maximum ring diameter 3.4 cm. 6th-7th century A.D. (Acc.no.11.52) (bottom)

Two long cloak pins from Margam Beach, South Glamorgan. They are of Irish type, with zoomorphic (stylised animal) heads. Length 40.3 cm and 45.3 cm (curved). Probably 5th century A.D. (Acc.no.77.54H)

Copper-alloy 'Type G' penannular brooch from Longbury Bank, Dyfed, with white metal surface. Excavations at the site have also produced an important collection of imported pottery and glass of the 5th-7th centuries. Smaller than the earlier zoomorphic penannular brooches, the trapezoid terminals of the Welsh examples are often decorated by punched or cast lines or dots, and separated from their hoops by ribbing. Maximum outer ring diameter 4.2 cm. 6th-7th century A.D. (Acc.no. 90.65H) (top)

Incomplete copper-alloy pin, probably from a penannular brooch, from the Roman amphitheatre at Caerleon, Gwent. Length 5.3 cm. (Acc.no.35.119) (bottom)

Ringed pins probably evolved during the 5th and 6th centuries, with simple ornament concentrating on the pinhead. This developed into a plain pin with the ring inserted through a looped head or polyhedral/baluster shaped pin-head, a type which was adopted by the Vikings in the 9th century. The brooch-pin was a cross between ringed pin and pseudo-penannular brooch, and was popular in Ireland throughout the 8th-9th centuries

a. Pin with square head bearing ring-and-dot motifs on sides and top, from Castlemartin Burrows, Dyfed. A similar pin is known from Caerwent, Gwent. Length 9.9 cm. 7th-9th century A.D. (Acc.no. 29.449)

b. Copper-alloy ringed pin from Gateholm Island, Dyfed. The type is common in Ireland, and two examples are known from Caerwent, Gwent. Length 13.2 cm. 6th-9th century A.D. (Acc.no. 30.524/12)

c. Copper-alloy brooch-pin of Irish type from Lesser Garth Cave, Radyr, South Glamorgan. The sheet bronze ring is decorated with incised lines and ring-and-dot motifs to represent terminals. Length 10.7 cm. 7th-9th century A.D. (Acc.no. 20.359/11)

d. Ringed pin with decorated polyhedral head from Llanfair PG Anglesey, Gwynedd. One side of the head has a diaper key pattern, the other a quatrefoil interlaced knot. The ring is missing. The blade of the pin has on one side a simple step-pattern, and on the other a triangular knotwork pattern, both motifs familiar on later Early Christian monuments and on ringed pins from Ireland. Length 15.2 cm. 10th century A.D.

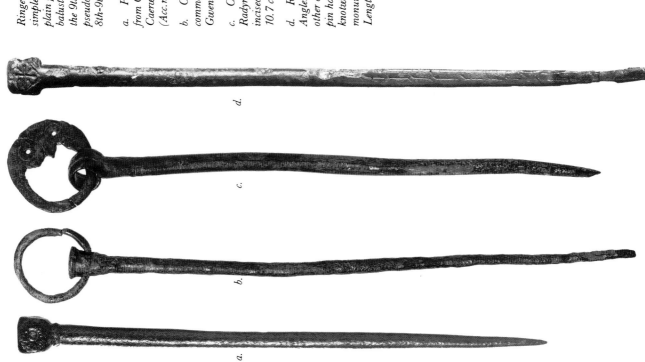

a.

b.

c.

d.

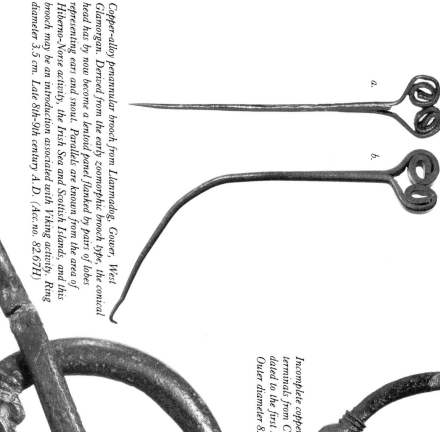

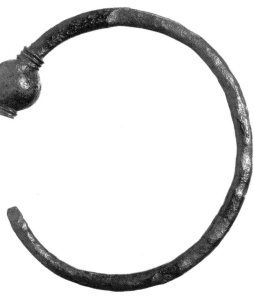

a. Double spiral-headed pin from Castlemartin Burrows, Dyfed. The shaft is a rolled sheet of metal, split at the head to form the twin-spiral design. Length 7.2 cm. 7th–8th century A.D. (Acc.no.29.449).

b. Double spiral-headed pin from recent excavations in the north-west corner of Roman Caerwent, Gwent. A similar, slightly larger iron double spiral-headed pin also from Caerwent is now with Newport Museum and Art Gallery. The bronze stem is split at the head, the 'arms' being turned into spirals. Curved length 9.2 cm. 7th–8th century A.D. (below)

Incomplete copper-alloy penannular brooch of 'ball-type' with plain terminals from Culver Hole, Llangynydd, West Glamorgan. Probably dated to the first half of the 10th century, and of Viking/Irish type. Outer diameter 8.8 cm. (Acc.no.31.118/2)

Copper-alloy penannular brooch from Llanmadog, Gower, West Glamorgan. Derived from the early zoomorphic brooch type, the conical head has by now become a lentoid panel flanked by pairs of lobes representing ears and snout. Parallels are known from the area of Hiberno-Norse activity, the Irish Sea and Scottish Islands, and this brooch may be an introduction associated with Viking activity. Ring diameter 3.5 cm. Late 8th-9th century A.D. (Acc.no. 82.67H)

Slate disc, trimmed to shape and decorated on both sides with scratched 'triquetra' knots, some incomplete. Such artefacts are called a 'motif-pieces', and many are believed to be rough drawings prior to the completion of a design. The original is in the Museum of Welsh Antiquities, Bangor. It is thought to come from a site at Aberglaslyn, Gwynedd. Width 5.0 cm. 9th–10 century A.D.

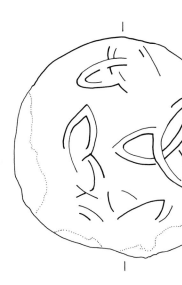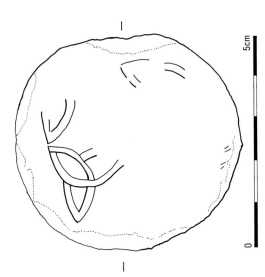

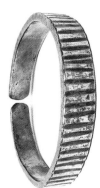

Silver arm-rings of Hiberno-Viking type discovered during quarrying operations near Red Wharf Bay, Anglesey, Gwynedd. Such rings form one of the commonest type of silver antiquity of Viking date in Ireland, and probably functioned as a form of currency. The Vikings were expelled from Dublin in A.D.902 (and re-established there in A.D.917). Viking finds along the coast of North Wales may have been left behind by refugees (such as followers of Ingimundr, who first attempted to settle on Anglesey, but was forced on to the Wirral). Early 10th century A.D. (Acc.no. 28.215/1-5)

The Early Church

Parts of Wales became Christian during the later Roman Empire. The presence of Christianity in early post-Roman Wales can be established from a number of sources, but they are, unfortunately, sketchy. Whatever its precise form, it should be seen as a development from the late Roman westward diffusion of the faith (eventually spreading to Ireland).

Later religious foundations in Wales can be indicated by the historical evidence of charters and law tracts. Early foundations are harder to identify, but they may be indicated by the archaeological evidence of concentrations of early inscribed stones, graves and curvilinear churchyard enclosures (which may represent early cemetery boundaries). Unmarked sites may be indicated by the place-name elements *llan* (enclosure) — for example, Llancarfan and Llanbadarn — or *merthyr* (from Latin *martyrium*) denoting the site of a reliquary of a saint — for example, Merthyr Cynog. In the south-east, a site may be referred to as a *podum* (monastery) in the 7th and 8th century, but as *llan* in the later place-name.

The monastery was one of the important features of the complex organisation of the early church in Wales. It is believed that a number of monasteries had become firmly established in Wales by the early 6th century. The presence of educated men acquainted with monastic values in 5th century Britain, and writings such as the lives of Samson and Illtud, founder of the monastery at Llanilltud Fawr (Llantwit Major) suggest possible roots in the late Roman devotional traditions (primarily amongst the landowners and nobles). The local monastery formed the base for further evangelisation, with dependant churches as centres for pastoral ministry. The Llandaff charters refer to 36 'monasteries' and 38 'churches' (called *ecclesia*, a term also used to refer to monasteries) in south-east Wales. It is not known whether such a large number would have been found in other areas. We know little about the institutional organisation of the church of this early period, but differences in composition and size existed. At least four sites had bishops (St David's, Bangor, Llandeilo Fawr, Llandaff), some had monks (for example, Bardsey and Caldey Island) and Llantwit had a 'great monastery'. Far from resembling Benedictine

houses of Europe, the Welsh religious community (*clas*) appears initially to have contained both regular monks and non-monastic clergy under an abbot (*abad*), who was a cleric (often a bishop), and later to have been composed largely of secular clergy. By the late 11th century many contained married clergy with children, rather than celibate monks. Minsters (or *clas* churches) with canons, and 'private' estate churches are known for the later period, containing the beginnings of the later parochial system of pastoral care.

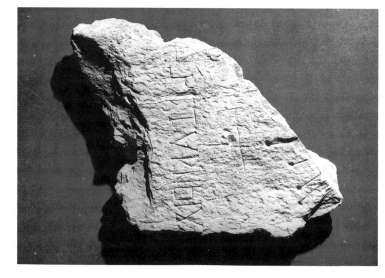

Anglo-Saxon inscription from Ramsey Island, near St David's, Dyfed. I1 probably comes from a large Early Christian burial site. The lettering reads: SI.|TURNBI\, *'The stone of St(a)turnbiu', referring possibly to Saturnbiu Hail ('the generous'), Bishop of St Davids (died A.D. 831). Height: 25.4 cm; width: c. 27.9 cm. 8th-9th century A.D. (Gal.18)*

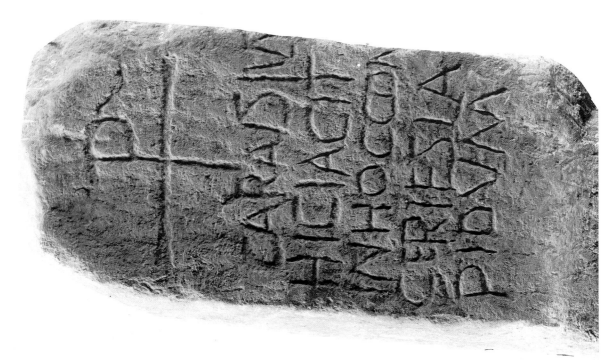

SAINTS

Dedications to principal saints suggest the influence of religious centres and popularity of their cults. Most prominent in South Wales is St David (Dewi), while others, such as St Teilo, St Cadog and St Gildas, gained a following abroad. The later *Lives* of several early saints of south-east Wales record the foundation of monasteries, for example, of Llanilltud Fawr (Llantwit Major) by Illtud, of Nantcarfan (Llancarfan) by Cadog, of Llandough by Cyngar/Docco, and of Llandaff by Dyfrig (Dubricius). The solitary or *eremitical* form of monasticism was closely linked to the communal form of monasticism, and the distinction between the two was not always sharp. The monastic communities frequently prepared monks for the road to solitude and prayer. Samson first moved from Llantwit to Caldey Island, then to a cave near the Severn, and as a bishop in the course of travelling set up three monasteries in Brittany and Cornwall.

The cult of saints was expressed in the veneration of places or relics. Objects and places associated with saints were viewed as being endowed with healing properties and the practice was recorded in the 12th century by Gerald of Wales: *'they pay greater respect than any other people to their churches, to men in orders, the relics of saints, bishops' crooks, bells, holy books and the Cross itself'* ('Description of Wales', *'Descriptio Cambriae'*, translated by Lewis Thorpe).

Some wells (such as St Seiriol's well, Penmon, Anglesey, Gwynedd; Holywell, Flint, Clwyd) have continuous patronage. Oaths were sworn on holy books, but saints' bones in particular were seen to have the greatest powers. The discovery in early cemeteries of special graves may indicate a focus for special devotion, as at Cae Capel Eithin, Gaerwen, Anglesey.

The stone of Carausius, from Penmachno, Gwynedd, dates from the 5th or 6th century. Below the Chi-Rho monogram the Latin inscription reads: CARAUSIUS/HIC IACIT/IN HOC CON/GERIES LA/PIDUM, *meaning 'Carausius lies here in this heap of stones'. Height 0.72 m (ECMW 101)*

BURIAL

Little is known of the burial rite associated with the early inscribed stones. The lead sarcophagus found at Ruddgaer, Anglesey indicates that practice was initially consistent with that of Roman Britain in some areas. Inhumation was customary. Amongst the early inscribed stones which appear to represent Christian burial, there are isolated examples which may mark the position of early cemeteries which are no longer visible, lying outside, but close to, existing churchyards. The stone known as 'Maen Madog' at Ystradfellte, near Brecon (Powys) of 5th- or 6th-century date, may have marked an isolated burial, though none has been found, while the 'Pillar of Eliseg' (Powys) stands on a barrow, and may have stood over a cist grave or small cairn. The stone from Penmachno (Gwynedd) records that 'Carausius lies in this heap of stones' ('CARAUSIUS HIC IACIT IN HOC CONGERIES LAPIDUM') implying a burial mound or cairn. Such isolated burial places are described in poetry:

The graves which the rain wets, —
men who had not been used to being provoked:
Cerwyd and Cywryd and Caw.

The grave of Rhun son of Pyd is in the rippling of a river
in the cold in the earth;
the grave of Cynon is at Rheon ford.

Whose is the grave on the mountain,
he who had led hosts?

The grave of Siawn the proud is on Hirenw mountain
between the earth and his oaken coffin,
smiling, treacherous, of bitter disposition.

(from *'Stanzas of the Graves',* Stanzas 1, 10, 33, 67,
translated by T. Jones)

The earlier burials appear to lie in isolated locations, the church lacking the authority or organisation to insist on, or to provide for, cemetery burial. Only gradually did burials become associated with churches, so that by the 11th century burial within the cemetery of a community had become common. Specially marked graves have been found beneath some churches, suggesting that certain burials became a focal point or shrine for the building of the church. A cist grave in the

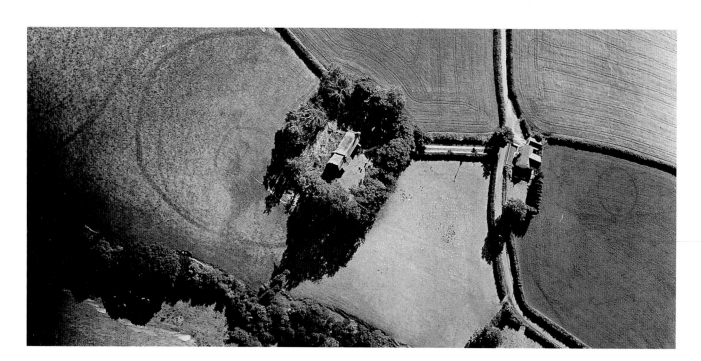

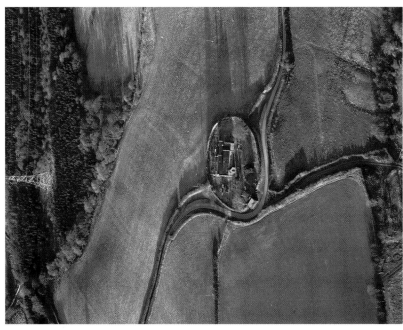

Circular churchyard, St Cynog's, Llangynog, Dyfed. (Photograph by permission of Dyfed Archaeological Trust)

churchyards are situated close to defended enclosures or hillforts, such as Llanafan Fawr (Powys) and Llangynog (Dyfed). A few church enclosures are segmented in Irish fashion, such as Llandyfaelog (Dyfed). Excavations by the Glamorgan-Gwent Archaeological Trust have recorded burials very near to the Roman villa and medieval church at Llandough (South Glamorgan), some dated to the 8th century. A cemetery at the Atlantic Trading Estate, Barry (South Glamorgan) comprised cist graves dating to the 4th to early 6th century. Island sites have certain associations with the period, and many are believed to possess early church sites, such as Burry Holms, Caldey Island and possibly the undated settlements at Gateholm and Priestholm.

apse of the church at Pennant Melangell (Llangynog, Clwyd) may be that of St Melangell (8th century), whose remains were subsequently translated to a shrine. Certainly the grave was still of importance when the apsidal church was built in the 12th century.

Archaeological excavation of some early cemeteries, usually within circular banks and ditches forming the enclosure (*llan*), has revealed burials in long cist graves made up of stone slabs. At Capel Maelog (Powys), recent excavations by the Clwyd-Powys Archaeological Trust have shown that a small inhumation cemetery had been established within an enclosure before the construction of the 12th century stone church. Wood from a coffin in one grave gave a late 9th — early 10th century radiocarbon date. Some circular or curvilinear churchyards originated as defended sites, possibly of later prehistoric date, as at Caer Bayvil and Eglwys Gymyn (Dyfed). Some churches with curvilinear

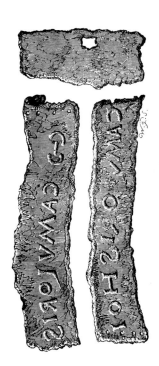

INSCRIBED LEADEN COFFIN FROM RHYDDGAER.

Lead sarcophagus discovered in 1878 at Ruddgaer, Llangeinwen, Anglesey, Gwynedd. Two of the sheets of lead bear the raised inscription CAMULORIS. The letters HOI on one side have been expanded to H(IC) O(SSA) I(ACENT) — 'Here lie the bones of Camuloris'. Probably 5th century: now in the Museum of Welsh Antiquites, Bangor. (Reproduced with permission from Archaeologia Cambrensis for 1878.)

Church at Llan-gan, Dyfed showing curvilinear churchyard and cropmark enclosure. (Photograph by permission of Dyfed Archaeological Trust) (left)

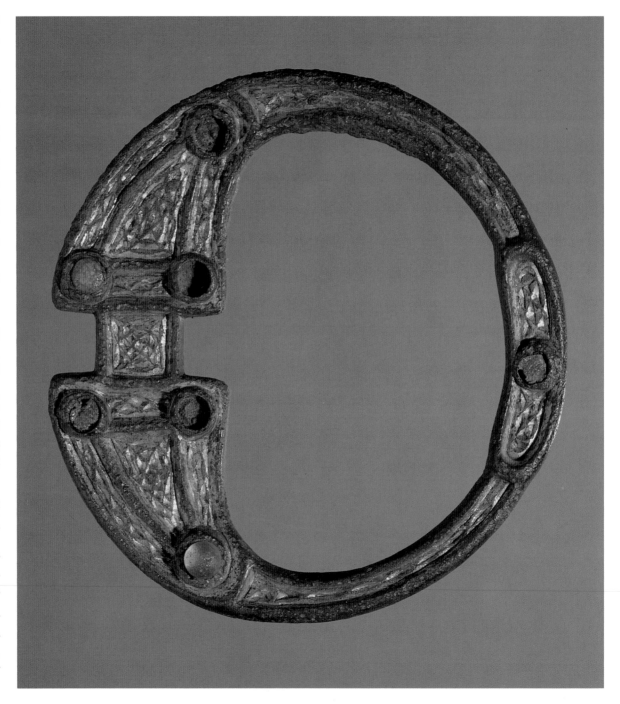

Pseudo-penannular brooch from Llys Awel Farm, Penycorddyn-mawr, Clwyd. Decorated with gilt chip-carved interlace, glass beads and amber studs, in Irish tradition. Diameter 7.3 cm. 8th century A.D. (Acc. no. 81.35H)

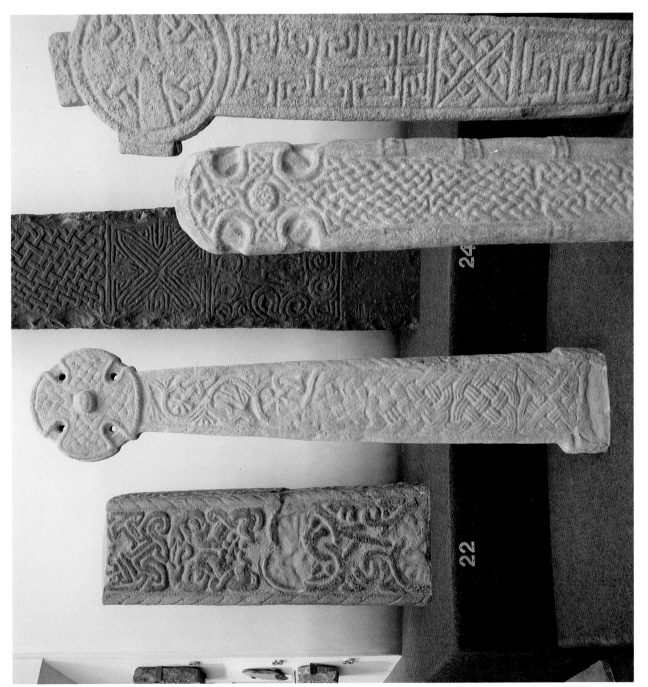

The Early Christian Monuments Gallery, at the National Museum of Wales

42

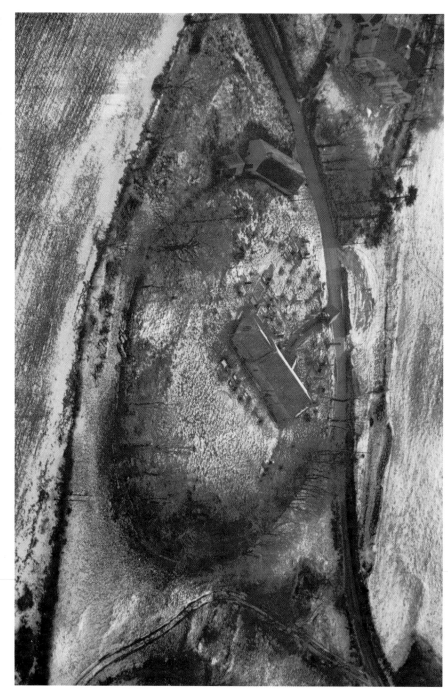

Circular churchyard, Eglwys Gymyn, Dyfed, which may have evolved from an early defensive site. The church has a Latin and ogam inscribed stone commemorating AVITTORIA, daughter of one Cunignus (Cynin), possibly a member of one of the principal saintly dynasties (ECMW 142). 5th-6th century A.D. (Photograph by T.A. James)

Scholars of the Stones

Our present understanding of the Early Christian monuments is the result of work of past scholars. One of the first to take active steps to record them was the antiquary Edward Lhuyd (1660-1709). Born in Oswestry, he was interested in fossils, antiquities and philology, and became eventually Keeper of the Ashmolean Museum in Oxford. Much of Lhuyd's work on Welsh antiquities, many now lost, was used for Edmund Gibson's 1695 English edition of Camden's *Britannia*.

In the 19th century interest in the monuments grew among both antiquaries and the general public. J.O. Westwood (1805-93), Professor of Zoology at Oxford, published many articles on Welsh Early Christian inscribed stones, and his *Lapidarium Walliae* (1876-9) was a notable achievement, describing for the first time most of the Welsh examples then known. While it frequently included later monuments and gave little information on the shape of the stones, it was not superseded until 1950. J. Romilly Allen (1847-1907), a lecturer in archaeology at Edinburgh and London, wrote the definitive two-volume *The Early Christian Monuments of Scotland* (1903), as well as a paper on *Celtic Crosses of Wales*, and *Celtic Culture in Pagan and Pre-Christian Times* (1904). A further more recent contribution was R.A.S Macalister's *Corpus Inscriptionum Insularum Celticarum* (1945, 1949), which still forms a standard work of reference.

The period between the two World Wars, however, saw the beginnings of the corpus of Welsh Early Christian monuments by V.E. Nash-Williams, Keeper of Archaeology at the National Museum of Wales. This appeared in 1950 as *The Early Christian Monuments of Wales*, and remains to this day a testimony to his dedication and prodigious industry. His classification and chronology of the monuments still forms the basis for the study of the subject by scholars today:

Group I Inscribed stones; 5th — 7th century
Group II Cross-marked stones; 7th — 9th century
Group III Cross-slabs and high crosses; 9th — 13th century

However, the dating of the stones is complex and this simple system of classification has its limitations. Inscribed stones will date after the 7th century and cross-marked stones before the 7th century. The Royal Commission Inventory of the Early Christian Monuments of Glamorgan has arranged them in groups according to their form and decoration:

Class A Inscribed stones of the early period
Class B Pillar-stones with incised cross
Class C Recumbent grave-slabs with incised cross
Class D Standing sculptured slabs, including sub-types
Class E Pillar-crosses, usually composite
Class F Other decorated stones
Class G Headstones and grave-slabs of the late period

However, for the purposes of this introduction, Nash-Williams's simpler classification has been retained.

Over the last 40 years a number of new stones have been discovered. Over 450 monuments are known; formerly there were far more. In accordance with recommendations by the Ancient Monuments Board for Wales (1956), some stones have been moved under protective cover, usually inside the church. Consequently their present locations may differ from those published by Nash-Williams.

Edward Lhuyd (1660-1709) from the Donation book of the Old Ashmolean

The cross of Hywel ap Rhys, ruler of Glywysing, subject of Alfred of Wessex in A.D.884. The half-uncial inscription reads (I)N INOMINE DI PATRIS ET S/PERETUS SANTDI ANC/ [C(?)]RUCEM HOUELT PROPE[R]/ABIT PRO ANIMA RES PA[T]/RES EUS, translated as 'In the name of God, the Father and the Holy Spirit, Hywel prepared this cross for the soul of Rhys his father'. Hywel ap Rhys died in A.D.886.

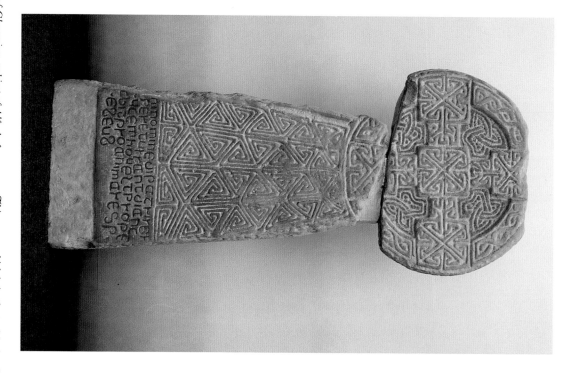

This cross, which is in the parish church in Llantwit Major, South Glamorgan, is one of the finest and earliest of the Welsh Group III monuments. The decoration, shallow triangular key-patterns in two paired bands, is similar to motifs found in illuminated manuscripts. The close similarity of the style of decoration and inscription to examples of the same date from Ireland suggests that it may have been the work of an Irish, or Irish-trained sculptor. Local gritstone. Height: 1.90 m. (ECMW 220; Gal. cast 27)

Fragment of decorated slab built into the external gable of the church porch at Llangamarch, Powys. Formerly built into the churchyard wall. 0.47m x 0.77m. 9th–10th century. (ECMW 57)

J.O. Westwood (1805-93), author of Lapidarium Walliae (1876-7). (top left)

J. Romilly Allen (1847-1907) shown measuring the 10th-century 'Samson' stone at Llantwit Major (ECMW 222). The side of the stone is decorated with a repeating diagonal key-pattern. It was re-erected inside the church in 1903. (bottom right)

V.E. Nash-Williams (1897-1955), author of The Early Christian Monuments of Wales (1950). (bottom left)

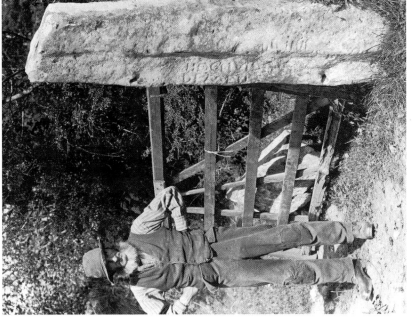

Many stones were found set in walls or re-used as gateposts. This 19th century photograph shows a Group I stone used as a gatepost on the road up to Little Trefgarne, St Dogwells, Dyfed. The Latin inscription reads: HOGTIVIS FILI/DEMETI, ('The stone) of Hogtivis(?) son of Demetus'. The ogam incised along the right angle may read upwards — HOGTEN(LO?) (ECMW 390). (above)

This illustration, taken from E. Donovan's 'Descriptive Excursions through South Wales and Monmouthshire in the year 1804 and the Four Preceding Summers (London 1805), shows the 'Ilquici' and 'Ilci' stones from Margam (ECMW 236 and 237) in use as a footbridge. This accounts for the wear across one side of each stone. (top left)

The cross known as 'Maen Achwyfan' ('The Stone of Lamentations') near Whitford, Clwyd, taken from Edmund Gibson's edition of Camden's Britannia (1695), which incorporated additions from Lhuyd (ECMW 190; Gal. cast 24) (bottom left)

The National Museum of Wales Collections

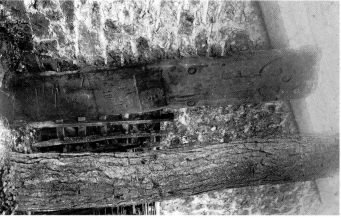

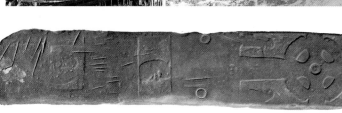

The first Early Christian monument to be presented to the Cardiff Free Library and Museum, precursor of the National Museum of Wales, was that from Bryn Cyneithin (West Glamorgan), by Archdeacon Griffiths of Carmarthen in 1892. Owing, in part, to the special interest in Early Christian monuments by past members of staff of the National Museum, it now holds some two dozen original stones, all of which are on display.

The original scheme to form a collection of casts of the pre-Norman inscribed and sculptured stones of the Principality was inaugurated in 1894, the first casts being the 'Conbelin' stone and the cross of 'Enniaun' (ECMW 234 and 231). The firm commissioned, Brucciani and Co., had established itself by 1866 as London's leading producers of plaster casts. Their methods of casting monuments involved the covering of carved details with gelatine sheet and substances inpenetrable to moisture, so that the clay and plasters employed in making the moulds were not in actual contact with the sculptured surfaces. Twenty one stones from Margam and Bridgend were cast in 1894 at a cost of about £230. In 1900, Mr W. Clarke of Llandaff was commissioned not only to continue with the moulding and casting of monuments, but also to search for 'any as yet undiscovered or forgotten', and by the beginning of the First World War casts of most of the principal stones in Wales had been added to the collection. Since then more casts have been made, the most recent in fibreglass resin, and their total number now stands at over one hundred.

In addition to finds from excavations in Wales, the Museum holds an important series of electrotypes of Irish metalwork, based on originals in the National Museum, Dublin. The Irish masterpieces have caught the eye of many modern jewellers, from the mid 19th century to the present day, and illustrate some of the influences on the art-styles found in Early Christian Wales.

Photograph taken in 1898 of the cross-slab at Nash Manor, South Glamorgan (10th century), now on display in the National Museum of Wales. This tall sandstone slab is decorated in low relief with a ringed cross, on each side of which stands a figure in profile, interpreted as the Blessed Virgin Mary and St John. Lower panels depict other figures. The style of the stone is similar to examples in North Britain and on the Isle of Man (ECMW 250; Gal. 26) (far left)

Front view of the cross-slab from Nash Manor, South Glamorgan. It is similar to slabs from Maughold, Isle of Man and Dunfallandy, Scotland. Height 2.65 m. (ECMW 250; Gal. 26) (left)

Inscribed stones, c.A.D. 400-650. They concentrate in West Wales, and are absent from the most Romanised areas of Gwent and Glamorgan. The occurrence of ogam inscribed stones in Brycheiniog, if a true reflection of their original distribution, suggests immigration of Irish-speaking people, possibly from Dyfed. Numbers refer to stones and casts in the Early Christian Monuments Gallery, at the National Museum of Wales). (right)

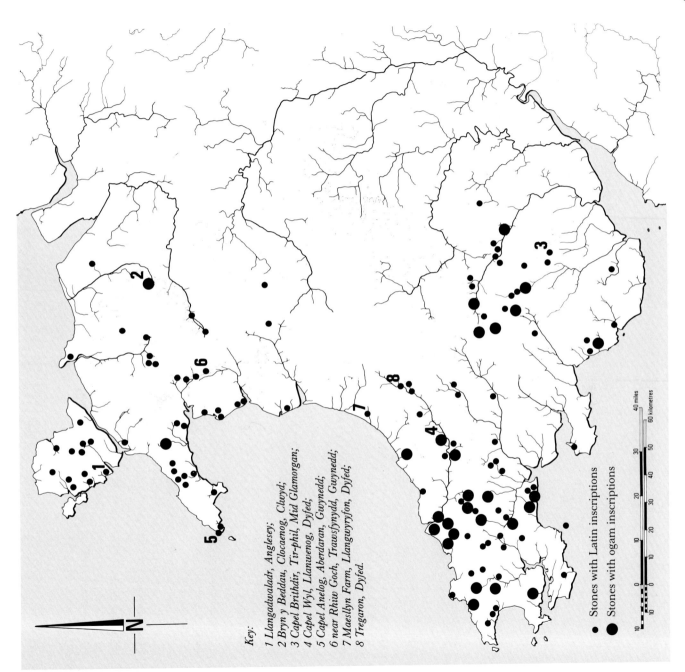

Key:

1 Llangadwaladr, Anglesey;
2 Bryn y Beddau, Clocaenog, Clwyd;
3 Capel Brihdir, Tir-phil, Mid Glamorgan;
4 Capel Wyl, Llanwenog, Dyfed;
5 Capel Anelog, Aberdaron, Gwynedd;
6 near Rhiw Goch, Trawsfynydd, Gwynedd;
7 Maesllyn Farm, Llangwyryfon, Dyfed;
8 Tregaron, Dyfed.

• Stones with Latin inscriptions

● Stones with ogam inscriptions

Main Types of Early Christian Monument

'A peece of much antiquity, with
Hyerogliphicks quite dismembred
And broken letters scarce remembred'

(from 'Vanity of Spirit' by Henry Vaughan,
published in *Silex Scintillans* (1650). It may refer to
the Scethrog pillar-stone, Powys (ECMW 68), now
in Brecon Museum.)

M any of the earliest surviving carved stones with Christian associations dating to the 5th-7th centuries come from Wales. They vary in size and shape, but most are large undressed boulders chosen for their natural regularity, which acted as tombstones, grave markers (indicated by the Latin formula HIC IACIT, meaning 'here lies') memorials or boundary markers between territories. The inscriptions record people of high standing in society, such as king Cadfan (CATAMANUS REX) of Gwynedd who died c. A.D.625, or Senacus the priest (SENACUS PRESB[IT]E[R]). Inscriptions often name the dead person's father, for kinship was important in tribal societies. While those commemorated probably all spoke an early form of Welsh or Irish, they are recorded in Latin. The earliest examples use Roman capital letters, while the later stones use half-uncials, a form of letter copied from manuscripts. A small group of monuments have Irish inscriptions in the ogam alphabet.

These early stones, classified as Group I by Nash-Williams, have been found in a wide range of locations: besides Roman roads, tracks or former ridgeway routes, in churchyards, or incorporated in recent times into walls or buildings. Their wide distribution suggests contact between Wales, Cornwall, Ireland and parts of Christian Gaul.

The stones of a second group (Nash-Williams's Group II) are decorated with incised crosses, usually without inscriptions. The execution of the design was often very crude. Most of the monuments of the Group II series were similar in form to Group I stones — upright pillars or slabs of natural or roughly hewn stone. However, unlike the previous monuments, some were,

for the first time, meant to lie flat above a grave — similar to modern gravestones. They are difficult to date, but it is generally believed that they first appeared during the 7th century.

The inspiration behind these new developments may have been Irish, although a number of recumbent grave-slabs with ring-crosses may have drawn on the decorated stones of Merovingian Gaul as an influential source. However, the makers of the cross-marked stones, which are common in North and West Wales, were slow to adopt some of the more advanced artistic devices of Ireland, Scotland and northern England. This has been thought to reflect the periods of isolation from the Roman church and from her neighbours which the Welsh church experienced, arising from differences of religious practice at this time.

The custom of erecting freestanding crosses in stone from the 9th century spread to Wales from adjacent parts of Britain. Crosses were no longer simple unhewn gravestones, but were the elaborate monuments of workshops under monastic or royal patronage. Structurally they fall into two broad types — cross-slabs and high crosses — forming Nash-Williams's 'Group III' of Early Christian monuments. They can be classified into fairly well developed forms, based on general structural forms. Ring-headed crosses are limited to North Wales, round-shafted pillar-crosses such as the 'Pillar of Eliseg', to North and Central Wales; disc-headed and wheel-headed slab-crosses to South Wales, moulded pillar-crosses and wheel-headed pillar-crosses also to South Wales. Regional styles can be recognised. In Glamorgan, a form known as a 'panelled' or 'cartwheel' slab emerged in the late 9th century (represented by examples from Margam). Another distinctive form was the 'disc-headed' cross type (at Margam and Llantwit Major). Characteristic of this new style was intricate surface decoration, copying ideas from metalwork and illuminated manuscripts. In common with sculpture beyond Wales, they were probably richly painted in different colours such as red (using haematite), orange, green (from verdigris) and black, sometimes on a surface smoothed with gesso or

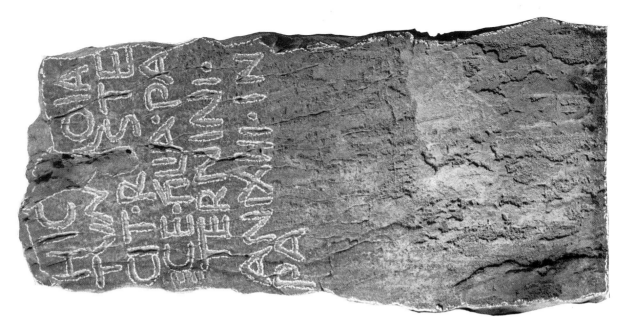

lime-based whitewash. Some apparently uninscribed slabs may have borne painted texts, while there is some indication on the 'Samson' cross from Llantwit Major that the inscription itself had been coloured for emphasis. An elaborate cross is carved over an earlier inscription on the stone from Defynnog, Powys (ECMW 44) and this would have been difficult to see unless the inscription had been whitewashed over, and the carving coloured.

Some crosses commemorated rulers or noblemen, such as the disc-headed stone erected by Houelt, or Hywel ap Rhys, a local king who died in A.D.886. Others may have acted as praying stations, while a number recorded the location or donation of land. Some crosses were so large that they were made in several sections. The Carew cross, with its inscription to Maredudd ap Edwin (ruler of Deheubarth from A.D.1033 to 1035), the cross from Penmon Deer Park (Anglesey, Gwynedd), that at Llandough (South Glamorgan) and the cross from Nevern in West Wales are of composite construction, with separate cross-heads attached to shafts by tenon joints. The famous 'Pillar of Eliseg' from near Llangollen, Clwyd, is the lower shaft of a cross erected by Cyngen, last of the kings of Powys (died A.D.854), in honour of his great grandfather Eliseg. The style of this cross is Mercian, with parallels in Cheshire.

The external influence of Irish, Anglo-Saxon, Northumbrian and Anglo-Scandinavian styles can be seen in the distribution of patterns on some freestanding crosses. It has been suggested that the sudden appearance of elaborate cross-slabs may have in part been a result of the decision by the Welsh Church to fall in line with practices of the Roman Church, following the settlement of the Easter controversy in A.D.768. However, the increasing importance of the cross symbol and the evolution of cross-decorated stones are likely to have contributed to the imperfectly understood origins of the Group III monuments.

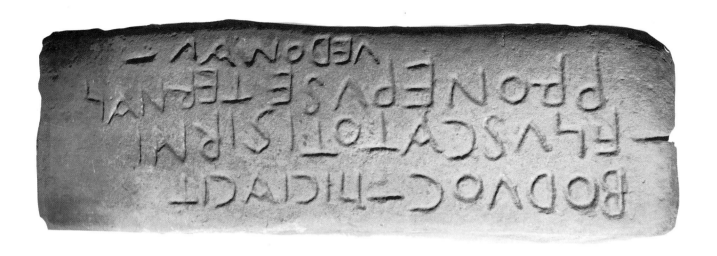

The ogam stone at Cwm Criban, Ystrad, Powys first recorded by Edward Lhuyd about A.D. 1695. The worn inscription probably reads: M[A]QI T[E]C[E]D. Height: 1.20 m+. 5th-6th century A.D. (ECMW 67a) (above)

Squared pillar-stone from Margam Mountain, West Glamorgan. The lettering of the inscription is almost completely in Roman capitals, and reads downwards: BODVOCI HIC IACIT/FILIVS CATOTIGIRNI/PRONEPVS ETERNALI/VEDOMAVI, 'The stone) of Bodvocus. He lies here, the son of Catotigirnus and great-grandson of Eternalis Vedomavus'. The 6th-century stone has been moved from the low mound on which it originally stood to the Margam Stones Museum. Height 1.15 m (ECMW 229) (left)

The stone of '(so-and-so), son of Avitori' at Pennachno, Gwynedd, which may have been set up in 'the time of Justinus the Consul' (A.D. 540), a formula used in western Gaul. The Latin when expanded could read: |FILI AVITORI// IN TE(M)PO[RE]/IUSTI[NI]/ CON[SVLI(S)], the first line reading vertically downwards, the others horizontally (as a separate inscription). An alternative reading of the horiontal inscription is INTEP[IDI// IUSTI[SSI(MI) CON[IUX], 'The grave of a most loving and righteous husband'. Height: 1.01 m. (far left)

The memorial to 'King Catamanus, wisest (and) most renowned of all Kings'. The Latin reads: CATAMANUS/ REX SAPIENTIS(S)I/ MUS OPINATIS(S)IM/US OMNIUM REG/UM. Catamanus (Cadfan in Welsh) was king of Gwynedd in the early 7th century. The inscription appears in a mixture of Roman capitals and 'half-uncial' letter forms derived from bookhands. This stone is at the church of Llangadwaladr, Gwynedd. Height: 1.22 m. 7th century A.D. (c.A.D.660?). (ECMW 13; Gal. cast 1) (left)

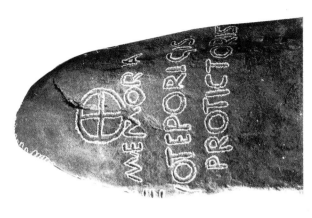

The memorial of 'Voteporix the Protector' or 'Vortipor' called 'the tyrant of the Demetae' by the monk Gildas in the mid-6th century. The Latin inscription reads: MEMORIA/ VOTEPORIGIS/ PROTICTORIS, 'The memorial of Voteporix Protector', and is partly mirrored in the ogam VOTECORIGAS (reading upwards). The ring-cross may be contemporary. This stone is from the churchyard of Castelldwyran, Dyfed, and now in Carmarthen Museum. Height: 2.11 m. (ECMW 138) (above)

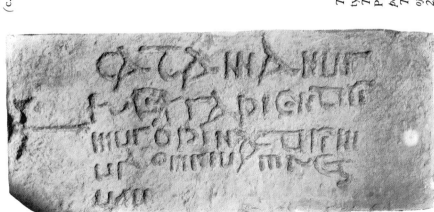

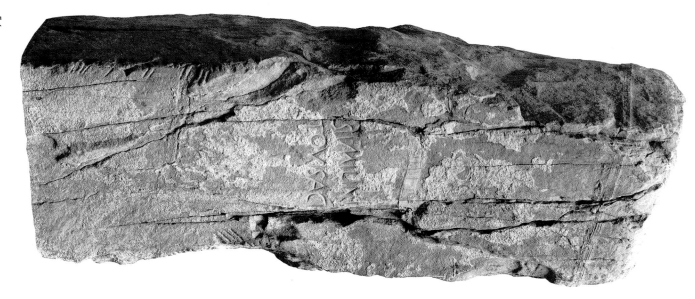

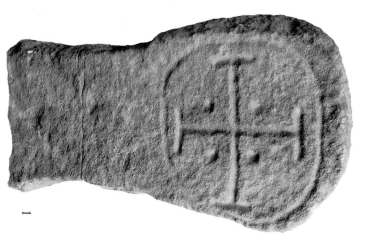

Pillar-crosses from — (1) Carn Caca, Melin-curt, Resolfen, West
Glamorgan. Height: 1.01 m. (Gal. 17); (2) Pont-rhyd-y-fen, West
Glamorgan. Height: 1.01 m. (ECMW 257, Gal. 15) (above)

The monument of SIMILINI TOVISACI, probably 'Similinus the
Prince...' from Bryn y Beddau ('Hill of the Graves'), Clocaenog,
Clwyd. The Latin inscription is mirrored by the ogam:
S[I]B[I]L[I]N[I] // [TO]VISACI. The genitive form of many names
is generally understood to mean 'The stone of'. Local sandstone.
Height: 2.13 m. (ECMW 176, Gal. 2)
(left)

1

2

Simple cross-slabs, dating between the 7th and the 9th centuries, were common in many parts of the Celtic West. These examples were found (1) near Port Talbot, West Glamorgan and (2) Llantrisant, Mid Glamorgan. Heights: 0.28 m; 1.0 m. (ECMW 260; Gal. 9 and ECMW 219) (Crown copyright. Reproduced by permission of R.C.A.H.M.W.)

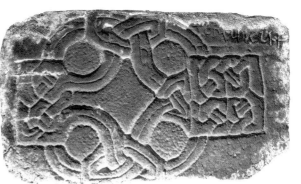

2

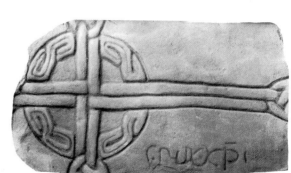

More elaborate cross-slabs incorporating new decorative devices, such as interlace and knotwork, begin to appear in the 9th century in Wales. Left, from Llangyfelach church, Glamorgan, inscribed CRUX.XPI ('The Cross of Christ') in half-uncials. Right, from Baglan, West Glamorgan is inscribed + BRANCU.F ('Brancu made it') in round half-uncials. Heights: 0.95 m; 0.70 m. (ECMW 211 and 191) (Crown copyright. Reproduced by permission of R.C.A.H.M.W.)

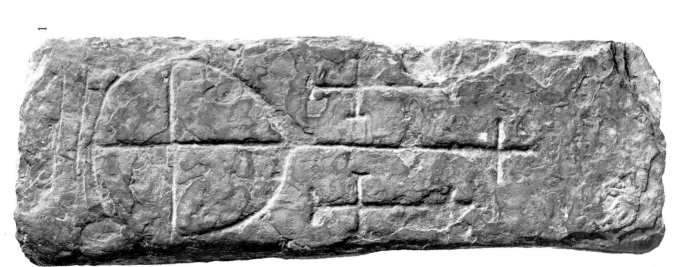

1

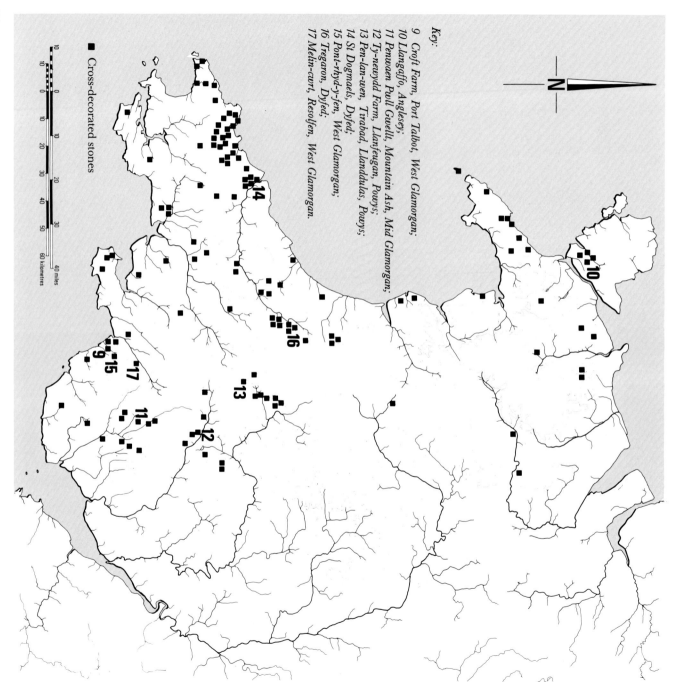

Key:

9 Croft Farm, Port Talbot, West Glamorgan;
10 Llangaffo, Anglesey;
11 Penwaun Poull Gwellt, Mountain Ash, Mid Glamorgan;
12 Ty-newydd Farm, Llanfeugan, Powys;
13 Pen-lan-wen, Tirabad, Llanddulas, Powys;
14 St Dogmaels, Dyfed;
15 Pont-rhyd-y-fen, West Glamorgan;
16 Tregaron, Dyfed;
17 Melin-cwrt, Resolfen, West Glamorgan.

■ Cross-decorated stones

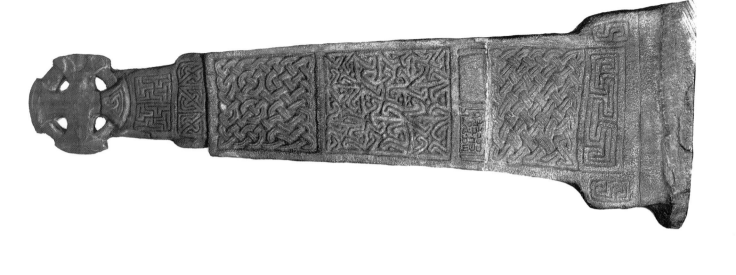

The stone from Capel Wyl, Llanwenog, Dyfed. The ogam reads upwards: TRENACCATLO, while the Latin expands on this, TRENACATVS/ IC IACIT FILIVS/ MAGLAGNI, 'Trenacatus lies here son of Maglagnus'. Height: 1.78 m. (ECMW 127; Gal. 4) (above)

This composite cross which stands by the roadside at Carew, Dyfed, was erected to 'king Margiteut son of Etguin' or Maredudd ap Edwin, who became ruler of Deheubarth (the kingdom of south-west Wales) in A.D.1033. The round half-uncials read: MARGIT/EUT.RE/ X.ETG(UIN).FILIUS. Maredudd was killed in A.D.1035 and the cross was probably erected after his death. Height: 4.12 m+. (ECMW 303; Gal. cast 29)

Cross-decorated stones, c. AD.600-1100.
The numbers refer to stones and casts in the Early Christian Monuments Gallery, at the National Museum of Wales (left)

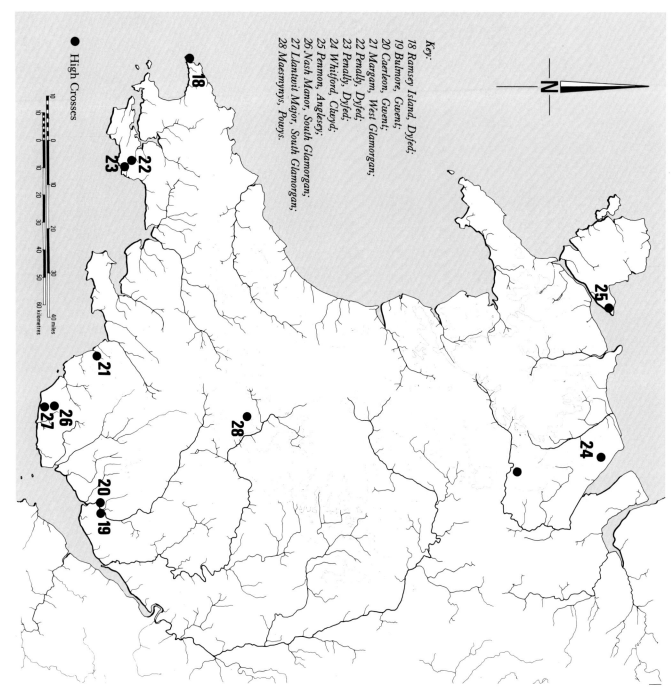

Key:
18 Ramsey Island, Dyfed;
19 Bulmore, Gwent;
20 Caerleon, Gwent;
21 Margam, West Glamorgan;
22 Penally, Dyfed;
23 Penally, Dyfed;
24 Whitford, Clwyd;
25 Penmon, Anglesey;
26 Nash Manor, South Glamorgan;
27 Llantwit Major, South Glamorgan;
28 Maesmynys, Powys.

N

● High Crosses

Language and Symbolism of the Stones

The inscriptions carved on the stones tell us a great deal about both the people of Wales, and the development of the Welsh language.

The majority of the earliest stones have inscriptions in Latin, often following the wording and style of inscriptions in Early Christian Gaul. Few formulae of late Roman inscriptions in Wales have a Christian bearing, and the tradition may have been introduced from outside. The 5th-century inscriptions are horizontal and use the formula HIC IACIT, a late Roman vulgar Latin form of HIC IACET, *'here he/she lies'* which was also popular in southern and central Gaul during the period *c*.A.D.420-460. The majority of surviving early inscribed stones occur in the less romanised areas of Wales, and a Gallic source for this type of memorial has been suggested. However, it is also likely that some British immigration took place in the 5th century into Wales from eastern parts of England. It has been argued that British monasticism had late Roman origins, with a similar indigenous development of the use of Latin-inscribed memorial stones. The earlier inscriptions also possess late Roman characteristics such as stops between words, the age of death and (rarely) a final phrase such as IN PACE ('in peace'). These early stones complement the evidence from the Lives of Samson, Illtud, Gildas and Patrick for the presence of Christian leaders and thinkers in 5th century Wales. Later inscriptions are inscribed vertically [top to bottom] in Celtic fashion, and the style of lettering initially follows standard Roman capital and cursive letter forms. This became gradually debased and by the end of the 6th century new letter forms based on bookhand were employed, called *half-uncial*, and *minuscule*. They remained in use throughout the Early Christian period.

Some Group I stones have inscriptions carved in Irish *ogam* script, an alphabet of 20 letters made up of groups of grooves set at different angles against or across a vertical base-line, usually the edge of an object or stone.

It is usual for the inscription to be placed on stone so that it could be read from the bottom up. The ogam alphabet is generally considered to be based on the Latin alphabet and its development in Ireland in the 3rd or 4th century A.D. (or earlier) has been associated with the use of wooden notched talley sticks, and of a manual sign language using fingers and thumbs. Three main theories have been proposed to explain its development — as a utilitarian method of carving on wood or stone, as a cypher to conceal information, or as a reaction against the Roman world. The most common occurrence of ogam on Welsh stones is on those with Latin inscriptions that repeat the Irish. Over 300 ogam stones are known in Ireland, where they are concentrated in the south or south-west of the country.

The Welsh distribution is limited, but most examples lie in the south-west (Dyfed), with a further group in Brycheiniog (now south Powys). Taken together with place-name evidence, this is thought to reflect the presence of Irish speakers in certain areas between the 4th and 7th centuries, as in Cornwall and south-west Scotland. It was used only for a short period up to about the end of the 6th century. The precise effects of this settlement are unclear, but later genealogies recorded that kings from the *Deisi* tribe of south-east Ireland (Leinster) had ruled for several generations in south-west Wales. Unlike its neighbours, Wales seems to have maintained a long tradition of using Latin.

Most of the inscriptions on Early Christian monuments are commemorative, recording the name and kinship of individuals, and occasionally their status (such as king or priest). For example, the 'Pillar of Eliseg' (ECMW 182) records and praises the achievements and kinship of Cyngen's great-grandfather, Eliseg. Inscriptions on Group III monuments are commonly set in panels, often defined by borders. It has been suggested that inscribed panels set low down on the shaft may be so positioned to be conveniently read when kneeling.

The simple requests for prayers or records of patrons and deceased were probably aimed at a wide audience. It is likely that important inscriptions would have been

The High Crosses, c.A.D.800-1000. The numbers refer to stones and casts in the Early Christian Monuments Gallery, at the National Museum of Wales. *(left)*

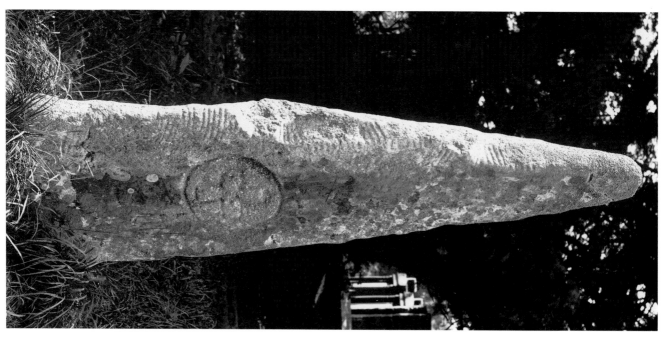

read or interpreted by those who could read to those (the majority) who could not. The inscription on the 'Pillar of Eliseg', for example, invites the reader to read the text aloud: [QUIC]UMQVE RECIT[A]VERIT MANESCRIP/[TUM LAPID]EM. The cross-slab from Llanwnnws, Dyfed (ECMW 125) asks for a prayer from those who are able to explain the inscribed name. Some phrases recall those used in charters and manuscripts books, such as those inscribed on stones from Merthyr Mawr (ECMW 240) and Ogmore (ECMW 255). Figure sculpture is rare in Wales, and the cross of Briamail Flou (ECMW 49) being a rare example of possible 'labelling' of the warrior depiction.

The Towyn stone, Gwynedd (ECMW 287) may bear the earliest example of the Welsh language inscribed on stone. The interpretation is uncertain in detail. The half-uncial inscription has been read and translated by the late Sir Ifor Williams as follows:

(a) Cengrui (or Tengrui) cimalted gu(reic)/adgan/
ant erunc du but marciau/
('Ceinrwy wife of Addian (lies here) close to Bud (and) Meirchiaw')

(b) cun ben celen: /tricet nitanam
('Cun, wife of Celyn: grief and loss remain')

(c) mort/ cic pe/ tuar
('The memorial of four')

(d) mc/ er tri
('This is a memorial of the three')

The half-uncial lettering of the inscription is comparable with 8th-century epigraphic forms, and the influence of manuscripts is evident in the tendency to run the lettering together. Welsh was well-established by c. A.D.800 as illustrated by the use of Welsh names in the Historia Brittonum (attributed to Nennius, c.A.D.800) and the Welsh form of the royal names on the 'Pillar of Eliseg'. It is anticipated by the form of Latin names on earlier stones such as CATAMANUS on the Cadfan stone from Anglesey, which may have been erected after his death, possibly by his grandson Cadwaladawr, who died in A.D.664 (ECMW 13).

The ogam-inscribed stone in Bridell Churchyard, Dyfed. The ogam inscription reads upwards NETTASAGRU MAQI MUCOI BRECI ('The stone) of Nettasagrus, son of the descendant of Brecus (or Brecos)'. The cross is thought to have been added around the late 9th century A.D. Height: 2.21 m. (ECMW 300)

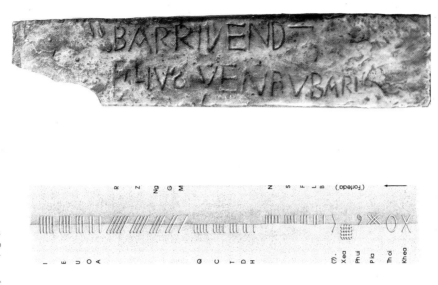

The ogam alphabet. It is phonetically based on consonant and vowel clusters which were established by Roman grammarians, and not the ABC alphabet. (left)

This monument from Llandawke church, Dyfed, shows that Latin and ogam inscriptions did not always commemorate the same person. The Latin reads: BARRIVENDI/ FILIUS VENDVBARI// HIC IACIT, ('Barriendus son of Vendubarus lies here'), but the ogam reads upwards 'DUMELEDONAS// MAQI M[UCOI], ('The stone) of Dumeledo, son of the kin of…') Height: 1.37 m. (ECMW 150) (right)

THE SYMBOLS

Symbols and scenes, in addition to inscriptions, were carved on larger stones throughout Wales, as a means of communicating ideas. The Chi-Rho, though ancient and pagan in origin, was one of the earliest symbols to be adopted by the Christians as it formed the first two letters of the Greek word for Christ (XPISTOS). The uniting of these two letters, *Chi* and *Rho*, was a late Roman development. In the 5th and 6th centuries this was modified into the so-called 'monogrammatic' cross with hook on the upper arm. Variations of this form were carved in some of the earliest Christian stones in Celtic Britain and Ireland. In Wales, it can be seen on Group I stones from Penmachno (ECMW 101) and Treflys in Gwynedd (ECMW 106).

The cross was not adopted fully until the 5th century by the Christian West, and some of the earliest forms of the cross may have been modelled on debased forms of the monogrammatic Chi-Rho. The symbol is carved above inscriptions on Group I stones, such as at Llangadwaladr, Gwynedd (ECMW 13) and Castelldwyran, Dyfed (ECMW 138). It may have influenced the development of the ring cross (so-called 'Celtic' cross), also derived from the encircled Chi-Rho symbol. By the 7th century the cross was the universally recognised symbol of Christianity. It developed from the plain form to ring crosses elaborated with dot or rings in the angles, the addition of cross bars, or the use of expanded terminals. Over one hundred variations of the simple cross have been recognised, falling into the three main categories of linear cross, outline cross and ring cross.

A different category of symbols is illustrated by the remarkable decoration on the Group I Latin and ogam inscribed stone from Trecastell, Powys (ECMW 71). At some point in its life this stone was inverted, and one face incised with elaborate designs, consisting of groups of symbols or pictographs and human figures, arranged in three panels.

A few of the Group II cross-decorated stones bear crude figural representations, two illustrating the crucifixion (ECMW 130, ECMW 337), while the stone from Llangamarch, Powys (ECMW 57) has associated spiral ornament and crude geometric figures, reminiscent of the Trecastell stone.

The cross acted not only as a symbol of God, but also of power and protection, and often records the patronage of the church and political rulers. The increased surface area of the later Group III monuments

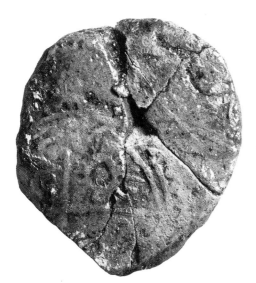

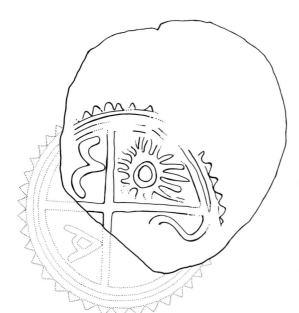

provided the craftsmen with an opportunity to extend the decorative repertoire of interlace. The designs include plaitwork and knotwork in three or more strands (up to 22, on the slab from Llangynnydd, West Glamorgan (ECMW 209)), the Stafford-knot, the triquetra motif (which may have symbolized the Trinity) and figure-of-eight knot, forms of decoration with a long history in Insular art. Animal-head terminals occur on the knotwork of the Margam 'Conbelin' stone (ECMW 234). The Scandinavian Borre style 'ring-chain' pattern common to sculpture in northern England and the Isle of Man falls under this decorative group. Interlocking patterns include key-patterns, T-frets, maze designs and 'swastika' patterns. Pellets occur occasionally with both fret-patterns and plaitwork.

The later Group III crosses and cross-slabs not only bear the decorative motifs characteristic of various artistic traditions, but some depict the stylized figures of saints, ecclesiastics, 'orantes' (from the Latin verb to pray: figures in the *orans* position, with arms raised, may represent a lay person, or priest vested and saying Mass) or angels in low relief. These religious associations are

reflected in their inscriptions. Most figure representations — and there are not many — are of iconographical significance, and are symbolic rather than representational. The most frequent religious scenes depict the Crucifixion (a common scene on Irish crosses and metalwork plaques), but others include Jacob wrestling with the Angel (Genesis 32, 24+) and the Temptation of St Anthony (at Penmon, Anglesey: ECMW 38).

Foremost among the secular scenes is that of the warrior. Scenes of huntsmen on horseback, often chasing a stag, may be allegorical, and it has been suggested that the two riders on the pedestal of the Margam 'Conbelin' stone (ECMW 234) have each been 'sanctified' by a triquetra knot, so that the scene could be interpreted as representing SS Peter and Paul, 'those two most fiery steeds of the Spirit of God'. A small figure with a horn or short bow in one hand and a small cylindrical object in the other below Christ on the cross-head from Llan-gan (ECMW 207) has been interpreted variously as Mary Magdalene holding a phial of ointment, Adam redeemed by Christ's blood, or David.

A 6th century pottery roundel from Dinas Emrys, Gwynedd stamped with a ringed monogrammatic Chi-Rho symbol (38 mm x 34 mm) (Acc. no. 57.299)

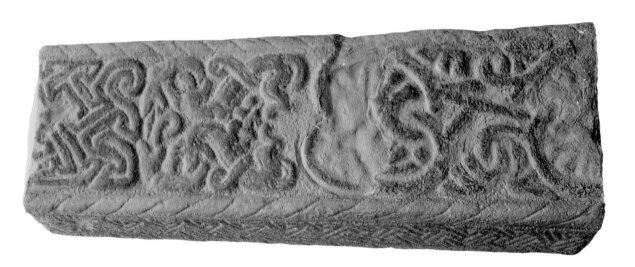

Shaft from a pillar-cross from Penally church, Dyfed. One side is decorated with diagonal key-pattern and pair of confronted animals of Northumbrian style. An indication of its appearance when coloured has been given. Height: 1.65+m. (ECMW 363; Gal. cast 22)

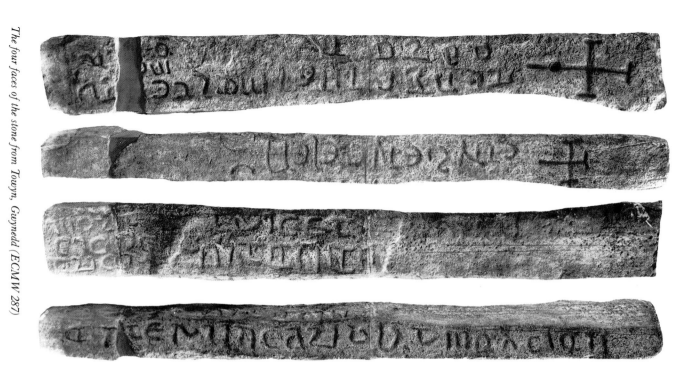

The four faces of the stone from Towyn, Gwynedd (ECMW 287)

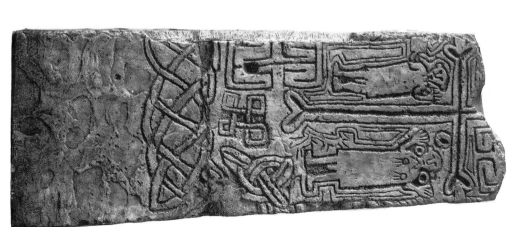

Decorated slab from Llanhamlach, Powys. The stone is covered in symbols and designs, but the cross is central to the design. The male figure on the left is clad in a straight tunic, and holds a square object in his right hand, possibly a book (psalter?). A taller female figure on the right of the cross in a similar tunic has arms raised in orans attitude. A small animal (dog or lamb?) is depicted virtually on the same side. The lance and sponge bearers were traditional in Irish and Hiberno-Saxon crucifixion scenes, but St John and Mary are more usual in contemporary Saxon depictions. Latin inscriptions in round half-uncials read downwards [...]OHANNIS, and MORIDIC SUR(r)EXIT/ HUNC LAPIDEM ('Moridic raised this stone'). Height: 1.16 m. (ECMW 61)

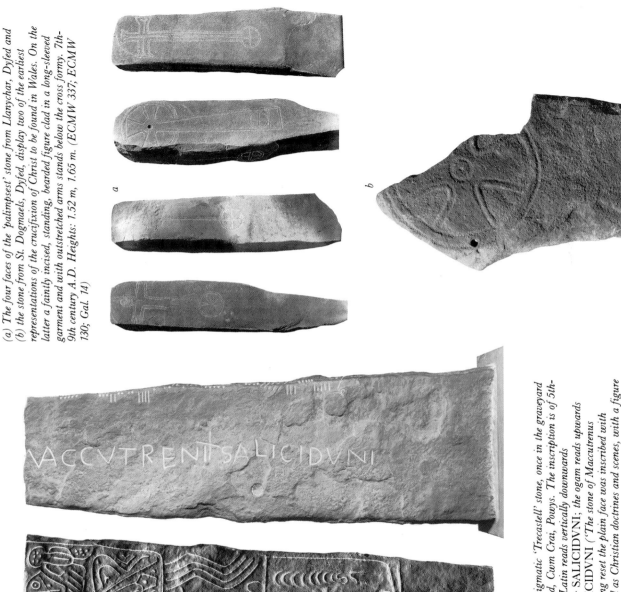

(a) The four faces of the 'palimpsest' stone from Llanychar, Dyfed and (b) the stone from St. Dogmaels, Dyfed, display two of the earliest representations of the crucifixion of Christ to be found in Wales. On the latter a faintly incised, standing, bearded figure clad in a long-sleeved garment and with outstretched arms stands below the cross formy. 7th–9th century A.D. Heights: 1.52 m, 1.65 m. (ECMIW 337; ECMIW 130; Gal. 14)

The two sides of the enigmatic 'Trecastell' stone, once in the graveyard of the former Capel Ilud, Cwm Crai, Powys. The inscription is of 5th–6th century date. The Latin reads vertically downwards [M]ACCVTRENI + SALICIDVNI; the ogam reads upwards MAQITRENI SALICIDVNI ('The stone of Maccutrenus Salicidunus). After being reset the plain face was inscribed with pictographs, interpreted as Christian doctrines and scenes, with a figure holding a crozier or shepherd's crook at the bottom. The precise meanings of these panels are uncertain. (ECMW 71) (above)

(By permission of the Trustees of the British Museum)

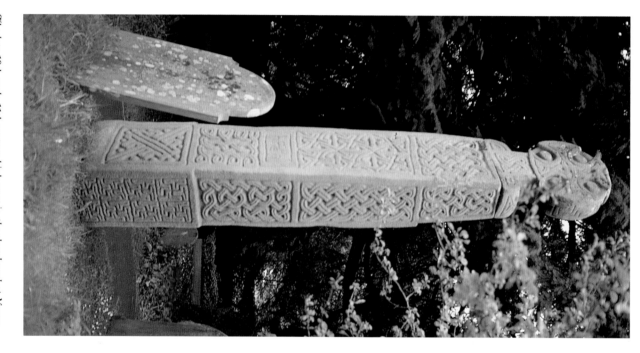

The late 10th-early 11th century high cross in the churchyard at Nevern, Dyfed. Height: 3.96 m. (ECMW. 360) (Photograph by H. James)

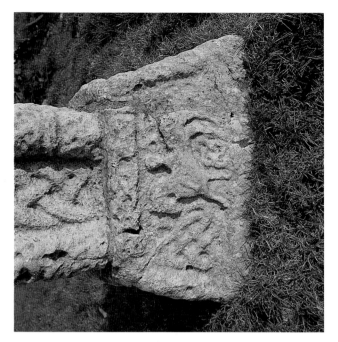

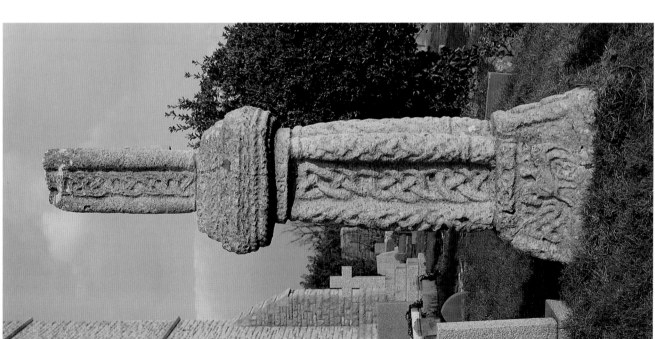

The pillar-cross at St Dochdwy's churchyard, Llandough, South
Glamorgan with detail of horseman on base. This late 10th or early
11th century composite cross consists of four moulded blocks. It is
inscribed IRBICI, 'The Stone of Irbic', and may be associated with the
postulated monastery enclosure referred to in the 'Life of St Cadog'.
Sutton Stone (ECMW 206; Gal. cast 32). The top element of a cross
of Llandough type can be seen at Llandaff, South Glamorgan

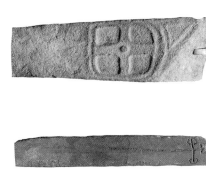

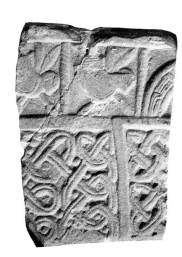

Sandstone disc-headed cross-slab from Llan-gan, West Glamorgan. The large figure of Christ is flanked by smaller figures of the sponge-bearer Stephaton (left) and spear-bearer Longinus (right). The rendering of the Crucifixion is reminiscent of similar scenes on Irish metalwork. Probably late 9th or 10th century. Height: 1.3 m. (ECMW 207) (right)

Pillar-crosses. On the left, from Tregaron churchyard, Dyfed. Height: 0.63 m (ECMW 133. Gal. 16). On the right, Mountain Ash, Mid Glamorgan. Local Pennant sandstone. Height: 1.35 m. (ECMW 249; Gal. 11). The former is inscribed ENEVIRI on the left side in low relief and the latter shows clear signs of 'pecking' to form the cross.

A portion of a cross-slab from Caerleon churchyard, Gwent, which has part of the wheel of a wheel-cross and part of its stem filling the space. Note the bird-like winged angels with traces of incised decoration on their bodies. Height: 0.40 m. (ECMW 291; Gal. 20)

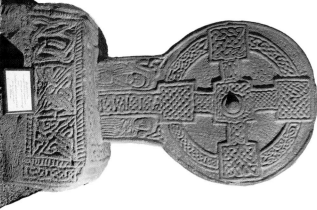

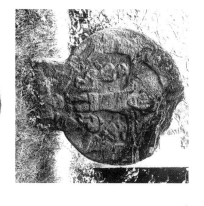

This cross-head and base (lacking part of its shaft) is a product of late 9th- or 10th-century school of craftsmen at Margam, and may be of Irish inspiration. The figures below the cross are likely to be representations of St John and the Blessed Virgin Mary. The inscription CON/BELIN P[O]/SUIT [.]/AC[C?]/RU// CEM/P [pro] [A]/NIMA RI[C?]/T/... may mean 'Conbelin erected this cross for the soul of Ric...' It was found at Margam Abbey, West Glamorgan. The shaft was fractured before A.D.1690 (see below for reconstruction). Local Pennant sandstone. Height: 2.25 m. (ECMW 234; Gal. cast 31)

Schools of Sculpture

For our knowledge of the techniques used in making the Early Christian monuments we are dependent on scrutiny of the monuments, analysis of the design construction and a few literary references. In general, natural boulders were modified to varying degrees. The early stones are unhewn pillar stones, though many of the earliest Group I inscriptions are cut on a dressed and prepared face. Occasionally Roman material was reused, such as the altar from Loughor (West Glamorgan) with a damaged ogam inscription on one angle which reads upwardsLICA, translated as 'The stone oflica' (ECMW 228). A sandstone pillar from Port Talbot started life as a Roman milestone, but in the 6th century an inscription was added commemorating CANTVSVS PATER PAULINUS ('Here lies Cantusus. His father was Paulinus'; ECMW 258). A distinction can be made in Group I stones between those inscriptions and designs which appear pecked and those which appear incised. Few stones show evidence for being dressed to a regular shape, whereas some later cross-incised stones show a development in the preparation of the stone. The 'Enevir' pillar stone from Tregaron, Dyfed bears a cross in low relief, the quadrants of the work having been carved away, and it illustrates the transition from incised to sculptured works in relief.

The appearance, from the 9th century, of elaborate, large, freestanding monuments with locations centred on early ecclesiastical sites suggests for the first time the existence of workshops or schools of craftsmen. To judge from the characteristics of the various local styles and their distribution, these 'workshops' were under the patronage of wealthy monasteries and churches. This is suggested by the extremely localised distribution at sites such as St David's, in Pembrokeshire (Dyfed), and Margam and Llantwit Major in the Vale of Glamorgan.

Some craftsmen may originally have travelled to Wales from neighbouring areas. It is unclear whether the growing wealth of the monastic communities attracted them, or whether raiding had ravaged the monasteries and churches of their homelands. Whatever the reason, these craftsmen would have brought with them their own particular regional styles. It is extremely difficult to state with certainty whether the choice of a particular motif was up-to-date, or a revival. Decorative patterns could have been copied or modified from illuminated manuscripts and portable works of art sent from one monastic house to another. On the later Welsh monuments we find examples of plant-scroll (vine-scroll) patterns favoured by the Anglo-Saxons, primarily in Northumbria, 'twin beasts', animals and birds (found on sculpture from Mercia and Northumbria). Complex key- and fret- patterns and interlace (in the form of plaitwork and knotwork) have parallels in Ireland, and the Anglo-Scandinavian style ring-chain and key-patterns of the 10th century can be found at many sites around the Irish Sea. The regional or 'workshop' production can be seen as a response to varied accumulations of influences.

In general, locally available stone was selected by the stone-carvers. The sculptors of these later slabs would have employed a similar range of equipment (such as hammers, picks, punches and chisels) and techniques (such as pocking and smoothing) as the earlier craftsmen, though the removal of considerable amounts of stone to create the deeper relief designs required longer times and greater labour. Unfinished Irish freestanding sculpture suggests that the patterns were first sketched out on the stone and then blocked out in rough relief. Once the background had been deepened and the interlace executed, the head of the cross and figures would be completed. The craftsmen probably had access to pattern books or motif-pieces as well as specialised tools such as compasses and dividers. A slate motif piece possibly from Aberglaslyn (Gwynedd) bears scratched triquetra motifs and is similar to examples from Viking Dublin. Comparisons exist between the layout and content of clearly defined panels of different shapes and sizes in stone and the ornament on decorated pages and outline motifs of illuminated manuscripts and the panels on ornamental metalwork of Insular style. Once the carving was finished it is likely that the final work was undertaken by the painter. All traces of such paint have generally now weathered away.

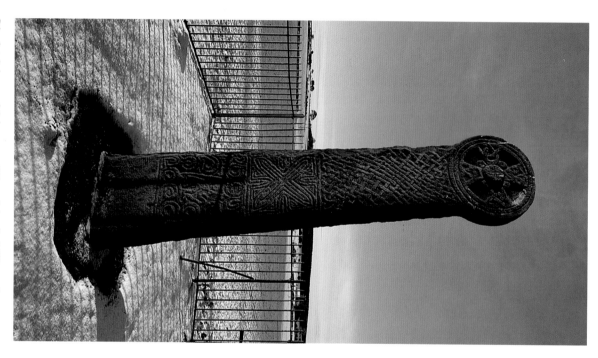

Disc-headed cross-slab known as 'Maen Achwyfan' ('Stone of Lamentations') near Whitford, Clwyd. The style of the decoration is related to that on Northumbrian crosses. Height: 3.32+m. Late 10th-11th century A.D. (ECMW 190; Gal. cast 24) (Photograph by P. Humphries)

A page from Rhigyfarch's Psalter, executed in Irish style at Llanbadarn Fawr in the 11th century. (By permission of the Board of Trinity College, Dublin)

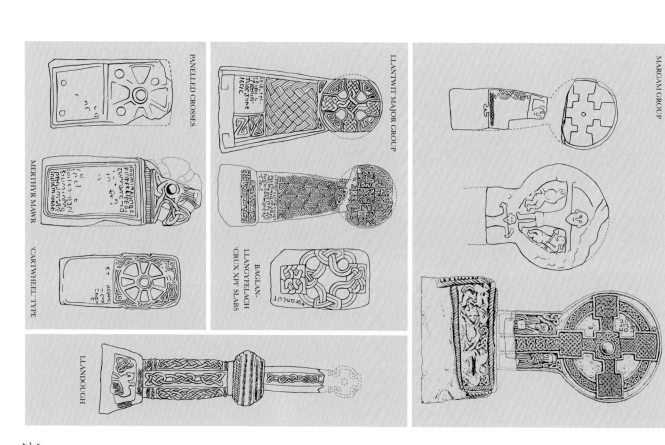

PANELLED CROSSES

MERTHYR MAWR

'CARTWHEEL' TYPE

LLANTWIT MAJOR GROUP

BAGLAN-
LLANGYFELACH
'CRUX XPI' SLABS

LLANDOUGH

MARGAM GROUP

Examples of local styles.
The crosses of Glamorgan

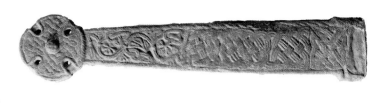

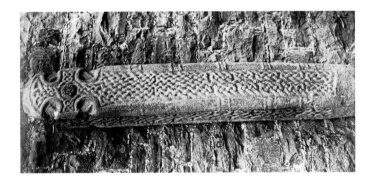

The 'Pillar of Eliseg' actually records the person responsible for writing the text of the inscription:

+ CONMARCH PINXIT HOC/
CHIROGRAF(I)U(M) REGE SUO POSCENTE

'Conmarch wrote (literally 'painted') this text at the command of his king'

That some crosses were made in wood is suggested by cross forms with spiked feet copied in outline on early stones (for example the 'Enevir' stone from Tregaron, Dyfed: ECMW 133). The use of mortice and tenons on the large composite crosses may also reflect timber construction practice. It is likely that woodcarvings, now lost, formed an important influence on inscriptions and designs. Certainly the decorated pillar shafts from Llantwit Major (ECMW 224 and 226) resemble in form wooden architectural columns cut with vertical V-shaped grooves to hold planks or panels, possibly as part of a chancel screen, and it has been suggested that the 'Pillar of Eliseg' shaft form is derived from the shape of a modified tree-trunk.

Few surviving Welsh Group III monuments approach those of Ireland and Northumbria in technical quality. Nevertheless, characteristic Welsh forms, such as the composite 'slab' and 'pillar' crosses and the 'panelled cartwheel' crosses from Margam, remained in fashion into the Norman period, when they began to be replaced by Romanesque forms.

The 'Neuadd Siarman' pillar-cross from Maesmynys, Powys. The moulded edges of the shaft have parallels in Saxon England. The quality of the knotwork and interlace on all four faces is very high. Late 9th-10th century A.D. Height: 1.77+m. (ECMW 65; Gal. cast 28) (top left)

Freestanding monolithic pillar-cross from Penally, Dyfed. The head and shaft are edged with thin cable-mouldings at the angles, and decorated on all faces in low relief. Notable are the single vine-scroll of Northumbrian type, double-beaded stem with interlacing of the tendrils, and the knotwork. (ECMW 364; Gal. cast 23) (top right)

Sandstone cross of 'panelled cartwheel' type from Pen-y-fai, Mid Glamorgan. Feint traces of letters on the shaft indicate a former pecked inscription in 4 lines. Possibly re-used as a boundary marker. 10th century. Height: 1.27m. (Gal. 34) (left)

Although the top of this cross from Llanfynydd, Dyfed is missing, it is recognisable as a southern Welsh type of the 10th century. Once again the panelled patterning is mainly Irish in inspiration and was perhaps derived from manuscript decoration. This cross commemorates EIUDON. Height: 2.08 m. (ECMW 159; Gal. 30) (far left)

74

Evangelist from the Lichfield Gospels (The Gospels of St Chad). The Welsh manumission around the margin was added in the 9th century. (By permission of the Dean and Chapter, Lichfield Cathedral)

Local schools of carving c A.D. 900-1100. The numbers refer to stones and casts in the Early Christian Monuments Gallery at the National Museum of Wales. (right)

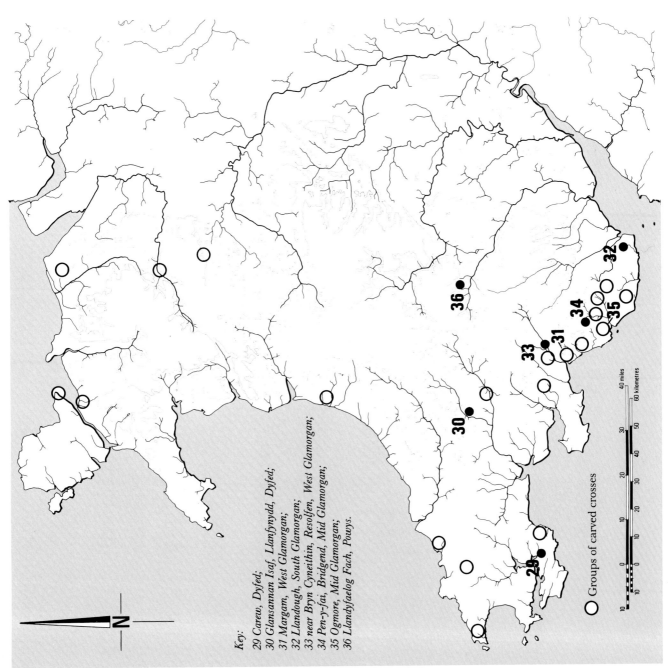

N

Key:

29 Carew, Dyfed;
30 Glansannan Isaf, Llanfynydd, Dyfed;
31 Margam, West Glamorgan;
32 Llandough, South Glamorgan;
33 near Bryn Cyneithin, Resolfen, West Glamorgan;
34 Pen-y-fai, Bridgend, Mid Glamorgan;
35 Ogmore, Mid Glamorgan;
36 Llandyfaelog Fach, Powys.

○ Groups of carved crosses

ENCIRCLED PATTERNS

SPIRALLED PATTERNS

DIAPER 'SWASTIKA' KEY PATTERNS

TRIANGULAR KEY PATTERNS

'SQUARE KEY PATTERNS AND 'T' FRETS FOR STRAIGHT LINES

SIMPLE PATTERNS

HALF PATTERNS

2-STRAND 6-STRAND

22-STRAND PLAIN PLAITS

BASIC INTERLACE PATTERNS

'SWASTIKA' T-FRETS

DIAGONAL KEY PATTERNS ('SWASTIKA' TYPE)

RING-CHAIN

Trade and Contacts

Wales was not isolated politically or culturally from the rest of Britain, or even Europe, in the Early Middle Ages. Foreign goods did reach Wales — such as pottery from the Mediterranean and Gaul between the 5th and 7th centuries, glass vessels, metalwork and coinage from England, and the silks and wine cited in heroic poetry. Gallic contact with Britain and Ireland is suggested by references to *Britones nautici* and *naves Brittanicae*, and Irish ships 'full of divers merchandise' in the Loire area (in the *Lives of Saints Columbanus and Philibert*). Links with Cornwall are suggested by the adoption there, as in Wales, of the custom of erecting inscribed memorial stones.

Where transactions or gifts were involved, cows, swords, brooches, clothing, dogs, hawks, horses and even Saxon slaves are mentioned, and metalwork, wool and leather were probably traded. There is no evidence for coin production in Wales before the Norman Conquest, and the only extant penny of Hywel Dda, ruler of Deheubarth, was minted at Chester.

Wales drew on the same Celtic artistic legacy as England and Ireland, assimilating to differing degrees new ideas and Germanic and continental motifs on art objects.

Irish, Saxons and Vikings were all important influences in the development of art in Wales in a time of travelling ideas. The wanderings of the Gospels of St Chad, an illuminated book once in South Wales, show how objects, and with them artistic traditions and symbolism, could move from place to place in the baggage of wandering monks and travellers. Designs could also be approved and made in one medium, and be copied in another. There were not only political but also frequent cultural and religious contacts with Ireland over a long period, illustrated in part by the commemoration of Welsh saints in Irish martyrologies, the occurrence of metalwork of Irish type in Wales, and the Irish influences on the high crosses of North Wales in the Viking period. During the period of Viking raiding the monastery of Gallen in western Ireland was burnt (A.D.820). According to the Chronicles, it was restored by a group of Welsh monks — another example of contact between the two countries.

From the 7th century relationships with the kings of Mercia were poor, and the dyke systems of the late 8th century did little to halt raiding, often by the English. Developments in Saxon England and the 9th-century rise of the kingdom of Wessex saw a change in its relationship with southern Welsh kings who submitted to the overlordship of the Saxon king Alfred in return for protection. English political and cultural influences are apparent in the form of parts of the Welsh laws and the use of English names, and visible in the styles of some crosses. The close contact of the late 9th and early 10th centuries also resulted in portable objects leaving Wales, such as gospel books and psalters.

From the middle of the 9th century Wales, like England, was subject to Viking raids. The earliest recorded attack is the killing of Cyngen 'by Gentiles' in A.D.852. The Irish Sea from the 9th to 11th centuries has even been described as a 'Viking lake', dominated by Dublin, the Isle of Man and Chester (an important English port). Seen by some Welsh as natural allies, small numbers of Scandinavians settled, to judge from place-names along the coast (for example *Bards-ey*, Ramsey (*Hrafns-ey*), Caldey (*kald-ey*), Grassholm (*gres-holmr*), Anglesey (*Onguls-ey*), Milford (*melr-fjordr*) Fishguard (*fiskigardr*). As they began to settle amongst local Welsh communities, the Vikings, too, became converted to Christianity. By the 11th century some had become a source of fighting men for the Welsh kings. Their presence resulted in the introduction of new forms of ornament. One innovation was the hogback stone in the form of a house with curving ridge and boat-shaped ground plan, and occasionally zoomorphic terminals. One example can be found in Wales at Llanddewi Aber-Arth, Dyfed (ECMW 114). Anglo-Scandinavian ring-chain, knotwork and fretwork patterns can be found on some standing stones of Anglesey and Flintshire, though it is not clear whether they were catering for Scandinavian taste, local taste influenced by Scandinavian fashion, or by sculptors working within a Scandinavian decorative tradition.

A selection of interlace and plait patterns on Welsh Group III stones

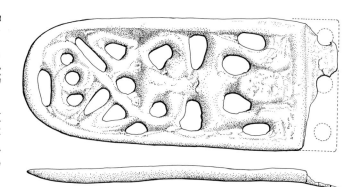

Fragment of 'Germanic' (Anglo-Saxon) gilt bronze buckle from Dinorben hillfort, Clwyd. Length 18 mm. 7th century A.D. (Acc. no. 58.585) (top centre)

Late Anglo-Saxon strap end of copper-alloy found at Monknash, South Glamorgan. Its form is identical with another from Winterbourne near Bristol and its presence reflects the links with late Saxon England. Length: 5.9 cm. 10th century A.D. (top left)

Oval lead weight of Viking type from Freshwater West, Castlemartin, Dyfed. It is decorated with a thin bronze mount depicting a back-biting quadruped. Lead weights were sometimes capped with scraps of Celtic or Anglo-Saxon metalwork cut from other objects. Length: 5.5cm; weight: 238.9 gm. 10th-11th century A.D. (Acc.no. 30.110) (bottom centre)

Terminal from a pseudo-penannular brooch of Irish type from Llys Awel Farm, Penycorddyn-mawr, Clwyd. At some point it had a loop of strip 'bronze' riveted to its rear to convert it to the head of a makeshift pin for a brooch. Traces of gilding remain. 8th century A.D. (Acc.no. 82.35H). (top right)

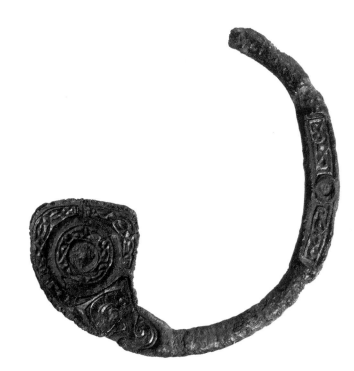

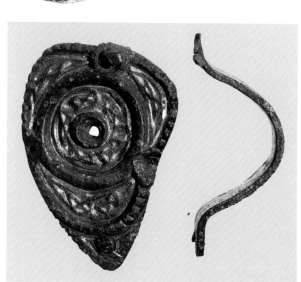

Pseudo-penannular brooch with some signs of gilding, from Trearddur Bay, Anglesey, Gwynedd. Irish type, 8th century A.D. Diameter 7.8 cm. (Acc.no. 80.102H) (right)

Sacred Treasures

Few religious works of art from Early Medieval Wales survive. There are very few portable objects such as precious books, no costly chalices, nor reliquaries, or other liturgical instruments as in Ireland. Some quadrangular handbells survive, though more once existed. Edward Lhuyd mentions several such saints' bells at the end of the 17th century, including three bells found on the unenclosed hillside near the church of Cwm (Clwyd) called *'Cloch Felen y Cwm'*, *'Cloch Wen Abergele'* and *'Cloch Las Llanddulas'*. Similar bells survive in Ireland, where approximately 60 are known, and Scotland. Few are decorated, and they are difficult to date. Some from South Wales, such as St Ceneu's from Llangenau (Powys), were cut from a sheet of iron, bent over, and fastened with rivets. The 6th-century British monk Gildas is reported to have forged his own bell. Others from North Wales, such as St Gwynhoedl's, from Llangwnnadl and St Cystennin's, from Llangystennin, were cast in solid bronze, making them among the largest surviving casts from the period. They belonged to a particular saint's monastery or church, and were venerated from an association with the saint's name. St Cadog's bell from Llancarfan, said to be the work of Gildas, was of sheet iron, and described as *varia* or mottled, a possible reference to a worn bronze plating. Gerald of Wales recorded the miraculous properties of a handbell at Glascwm supposed to have belonged to St David, and called a 'bangu'.

For other evidence we rely on documentary references to vanished ecclesiastical metalwork. The cult of the relics of local saints resulted in the creation of a variety of decorated shrines to house the holy remains. Many were made to be carried about, the larger ones being equipped with rings or loops for straps. Sometimes they are described being carried in flight away from some threat. For example, when Morgannwg (Glamorgan) was raided by Vikings and Saxons in A.D.1022, the monks of Llancarfan fled to Gwent carrying the shrine (*arca*) of St Cadog. They were attacked and one of the attackers broke off its gilt wing finial with an axe. In A.D.1089 the shrine of St David was stolen from his church, while 'a bell' made by Gildas was carried off in an English raid on Llantwit Major in the 10th century. The Gwytherin casket, otherwise known as the 'Chest of St Winifred' was sketched by Lhuyd in 1690. The casket from the church of St Winifred, Gwytherin, Gwynedd, was most probably a house-shaped reliquary plated in silver, and similar in overall form to St Manchan's shrine, now in Boher church, Co. Offaly, Ireland. If of Welsh workmanship, the Gwytherin casket was probably based on an English model, to judge from the style of the sketches of the decorative roundels.

Croziers were revered as relics of major saints. The brass head of St Baglan's crozier survived to the end of the 17th century, and the staff of Padarn, called Cyrwen, was praised in a poem by Ieuan, brother of Rhigyfarch:

Amdinnit trynit trylenn.
Amtrybann teirbann treisguenn.
Amcen creiriou gurth cyrrguenn.
Amdifuys daul bacl patern.

'Much accomplishing, much loved, it gives protection,
Its holy power reaching the limits of three continents.
No other relic can be compared with Cyrwen —
A wonderful gift — Padarn's Staff.

(Corpus Christi College, Cambridge, MS 199, reconstructed and translated by the late Sir Ifor Williams.)

Gerald of Wales describes a staff which once belonged to Saint Curig, in the church of St Germanus in Gwrthrynion. All encased in gold and silver, it had a top in the rough shape of a cross and was renowned for curing glandular swellings and tumours. The Life of St Tatheus describes a staff made from a golden fetter, presumably covered in decorative sheeting.

Gerald of Wales also describes seeing 'St Cynog's torque' at Merthyr Cynog. Used for solemn oath-swearings, it was a gold-coloured ring made in four welded sections, divided in the middle by *'a dog's head, which stands erect with its teeth bared'*. This description is reminiscent of copper alloy door rings with animal head mounts of Irish type dating to the 8th-9th centuries.

Illuminated gospel books provided sources of artistic ideas. The surviving Lichfield Gospels (The Gospels of St Chad) contain one carpet page of colourful designs, two Evangelist portraits and other decoration. Though

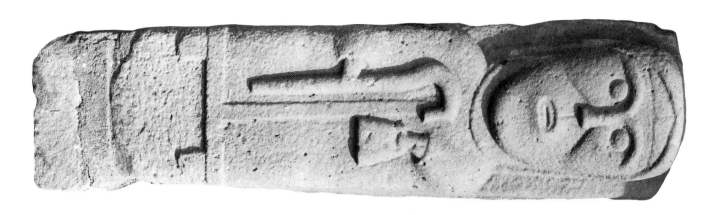

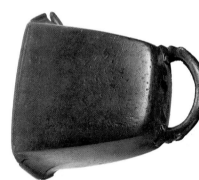

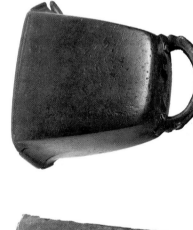

St Gwynhoedl's bell made of cast 'bronze', from Llangwnnadl church, Gwynedd. Its handle has animal-headed terminals. Height 17.1 cm. Date: 9th-11th century A.D. (Acc. no. 10.23) (above left)

St Ceneu's bell is made of wrought iron, from the site of St. Ceneu's chapel, Llangenau, Powys. Height 31 cm. (Acc. no. 21.416/2) (above right)

The two usual attributes of an early British or Irish cleric were his crozier and bell. This effigy is at White Island, Co. Fermanagh. 8th or 9th century A.D. (Crown copyright, by permission of the Controller of Her Majesty's Stationary Office) (left)

Sketch by Edward Lhuyd of the Gwytherin casket c. A.D.1696. The roundels appear to be of English design, and the overall work has been dated to the 8th century A.D. (By permission of the Bodleian Library, Oxford MS Rawl B 464 fol. 29ᵈ) (below)

Arch Gwenfrewi yn eg lwys Gwytherin yn Swydh ddimbech.

in Lichfield from the 10th century, and probably executed in Northumbria or Mercia in the 8th century, marginal texts record that the book was at Llandeilo Fawr, in the north of Ystrad Tywi, in the early 9th century. The gift was made by Gelli ab Arthudd who had purchased the book from one Cingal for a very good horse. It has been suggested that the book later travelled to England as a gift from king Hywel Dda to king Athelstan of Wessex and Mercia, who passed it to the Bishop of Lichfield, but the reasons for its departure from Wales are obscure. The marginal memoranda are important as the oldest surviving examples of secular records in the Welsh language, preserved by the sacred nature of the book. One of the few surviving Welsh manuscripts is Rhigyfarch's Psalter (the Psalter of Ricemarcus), made in the monastic *scriptorium* of Llanbadarn Fawr, Dyfed. It was written by the scribe Ithael and decorated in imitation of the book ornament of Irish *scriptoria* by Ieuan (IOHANNES), one of the sons of Sulien *c.*A.D.1080-81. Ieuan also transcribed and decorated the manuscript of St Augustine's *De Trinitate* (MS 199). The school of Llanbadarn was founded by Sulien, who was born in Wales *c.* A.D.1011. He taught his own four sons, amongst others, a style of decoration learnt during several years of training and study in Ireland.

These glimpses of treasures, many lost through the ravages of war, change and decay, illustrate the former diversity of the artistic heritage once associated with Early Christian Wales.

St Manchan's Shrine, Boher Church, Co. Offaly. The yew box is covered in gilt bronze and enamelled mounts in the Irish Urnes style. Date: 12th century A.D. (By permission of the Trustees of the British Museum) (above)

Scene depicting the coffin of St Cuthbert being carried on two poles by two men. St Cadog's shrine may have been transported in this manner. (By permission of University College, Oxford. Photograph by permission of the Bodleian Library, Oxford. MS University College 165 P. 159) (below)

Brief Guide to the Collection of Early Christian Monuments and Casts in the National Museum of Wales

(* = on display in the Museum's permanent gallery. They are original stones, unless otherwise stated. Old county names are used, following Nash-Williams.)

Place	Acc. no.	Nash-Williams no.
Anglesey		
Llangadwaladr*	cast 02.160	13
Llangaffo	cast 02.166	15
Llangaffo*	cast 02.163	17
Llangaffo	cast 02.164	19
Llangaffo	cast 02.175	21
Llangaffo	cast 02.162	22
Llangaffo	cast 02.165	23
Llangeinwen	cast 02.169	29
Llansadwrn	cast 02.161	32
Newborough	cast 02.160	35
Newborough	cast 02.173	36
Penmon*	cast Pro.84	37
Penrhoslligwy	cast 02.171	39
Breckncockshire		
Crickhowell	cast 06.482	43
Defynnog	cast 06.481	44
Llanafan Fawr	cast Pro 162	45
Llandetty	cast 06.485	46
Llandetty	cast 06.503	48
Llandulas*	cast 29.291/1 (loan)	49
Llandyfaelog Fach*	cast 06.484	51
Llaneleu	cast 06.484	52
Llanfeigan*	Pro 161	53
Llanfihangel Cwm Du	Pro 159	54
Llanfrynach	36.321	56
Llangamarch	06.478	57
Llangammarch	cast 06.486	58
Llangorse	cast 06.488	59
Llanhamlach	cast Pro 160	61
Llanlleonfel	cast 06.489	62
Llanwrtyd	cast 06.490	64
Llanynys*	cast 06.507	65
Patrishow	cast 06.493	67
Scethrog	cast 04.496	68
Trallwng	cast 06.497	70
Trecastell	cast 54.157	71
Ystradfellte	cast 06.495	73
Caernarfonshire		
Aberdaron	cast 02.178	77
Aberdaron*	cast 02.179	78
Bardsey Island	cast 02.156	82
Llanaelhaearn	cast 02.180	87
Llanfaglan	cast 02.182	89
Llanfaglan	cast 02.181	90
Llannor	cast 02.183	95
Cardiganshire		
Llandysul	cast 14.306/28	121
Llangwyryfon*	43.33	122
Rhuddlan*	cast Pro 35	127
Silian	cast 14.306/22	128
Silian	cast 14.306/23	129
St Dogmaels*	36.363	130
Tregaron*	35.618/1	132
Tregaron*	35.618/2	133
Carmarthenshire		
Cynwyl Gaeo	cast 14.306/15	139
Cynwyl Gaeo	cast 14.306/16	140
Cynwyl Gaeo	cast 14.306/20	141
Eglwys Gymyn	cast Pro 152	142
Henllan Amgoed	cast 14.306/35	144
Laugharne	cast Pro 154	145
Llanarthne	cast 14.306/4	147
Llanboidy	cast 14.306/33	149
Llandawke	cast Pro 102	150
Llanddowror	cast Pro 102	151
Llanddowror	cast Pro 177	152
Llandeilo	cast 14.306/7	155
Llandeilo	cast 14.306/8	156
Llandeilo	cast 14.306/26	157
Llanfihangel-ar-arth	cast 14.306/27	158
Llanfihangel-ar-arth	30.47	159
Llanfynydd*	cast 14.306/32	161
Llanglydwen	cast 14.306/3	162
Llangunnor	cast 14.306/14	163
Llangyndeyrn	cast 14.306/38	164
St Ishmael	cast 14.306/37	165
St Ishmael	cast 14.306/24	169
Llanllwni	cast 14.306/13	170
Llanpumsaint	cast 14.306/5	171
Llanwinio	cast 14.306/12	172
Merthyr	cast 14.306/9	173
Newchurch	cast 14.306/10	172
Newchurch	cast 14.306/11	173

Locations of Collections of Early Christian Monuments, with National Grid References

Museums

Museum of Welsh Antiquities, Bangor, Gwynedd

Brecknock Museum, Captain's Walk, Brecon, Powys

Carmarthen Museum, Old Bishop's Palace, Abergwili, Carmarthen, Dyfed

Cyfartha Castle Museum, Cyfartha Park, Merthyr Tudful, Mid Glamorgan

Margam Stones Museum, Old School House, Margam, West Glamorgan

National Museum of Wales, Cardiff, South Glamorgan

Royal Institution of South Wales Museum, Victoria Road, Swansea, West Glamorgan

Scolton Manor Country Park Museum, Spittal, Haverfordwest, Dyfed

Churches:

Dyfed —
Llanddewibrefi, Parish Church SN 67 55
Llanwnda, St Gwyndaf's Church SM 93 39
Nevern, Parish Church SN 08 40
Penally, Parish Church SS 12 99
St David's Cathedral SM 75 25
St Dogmaels Abbey and Parish Church SN 47 15
Tregaron Parish Church SN 68 59

Glamorgan —
Ewenni Priory Church SS 91 77
Llantwit Major Parish Church SS 97 68
Merthyr Mawr, St Teilo's Church SS 88 78

Gwynedd —
Llangaffo Parish Church SH 44 68
Llangeinwen Parish Church SH 42 99
Penmachno Parish Church SH 79 51
Penmon Priory, Anglesey, Gwynedd SH 63 89

Selection of Other Early Christian Monuments:

Carew, Dyfed SN 05 04

Llandough Churchyard, South Glamorgan ST 17 73

Llan-gan Churchyard, South Glamorgan SS 96 78

Llangernyw Churchyard, Clwyd SH 88 67

Llanrhaead-ym-Mochnant Parish Church, Clwyd SJ 12 26

Maen Achwyfan, near Whitford, Clwyd SJ 13 79

Meifod Parish Church, Powys SJ 16 13

Pillar of Eliseg, near Valle Crucis SJ 20 45

British Museum, London: Trecastell stone

References to illustrated material

This selective bibliography excludes V.E. Nash-Williams *ECMW*, which is already referred to in the picture captions.

Page no.

Frontispiece — C. Fox, 'The Re-erection of Maen Madoc, Ystradfellte, Breconshire', *Archaeologia Cambrensis* 95 (1940), 210-216

9 — Redrawn from W. Davies, *Patterns of Power in Early Wales* (1990)

12 — After *ESMW* (1989), Fig.1

11 — After J. Knight (forthcoming) *Post-Roman evidence from Caerwent*

13 — L. Alcock, *'Dinas Powys, An Iron Age, Dark Age and Early Medieval Settlement in Glamorgan'* (University of Wales Press, 1963)

16, 18 — L. Alcock, *op cit*; E. Campbell, 'Dinas Powys', *EMSW*, 59-61 and 127-130; J. Graham-Campbell, 'Dinas Powys Metalwork and the Dating of Enamelled Zoomorphic Penannular Brooches', *Bulletin of the Board of Celtic Studies* XXXVII (1990)

17, 20, 21, 23 — E. Campbell and A. Lane, 'Llangorse: a tenth century royal crannog in Wales', *Antiquity* 63 (1989), 675-681; E.N. Dumbleton, 'On a crannog, or stockaded island, in Llangorse lake, near Brecon', *Archaeologia Cambrensis* (1870), 192-198; M. Redknap, E. Campbell, and A. Lane, 'Llangorse crannog (SO 129 269)', *Archaeology in Wales* 29 (1989), 57-58; M. Redknap, A. Lane and E. Campbell, 'New Light on Dark Age Wales'. In: Proceedings of the International Seminar 'Towards the Second Century of Archaeology in Sri-Lanka', Colombo. *Ancient Ceylon* 7 (1989), 209-225; M. Redknap, 'New Patterns from the Past', *Anguedd/a* (Winter 1990), 5; F. Pritchard, *in litt.*

28 (top) — *Glamorgan Inventory* Vol I, Part 3 (1976)

28 (bottom) — P. Barford, W.G. Owen and W.J. Britnell, 'Iron Spearhead and Javelin from Four Crosses, Llandysilio, Powys,' *Medieval Archaeology* 30 (1986), 103-6

28 (left) — *Medieval Archaeology* 13 (1969), 243

30 (right) — J. Knight, 'Glamorgan AD 400-1100: Archaeology and History', *Glamorgan County History Vol.2* (1984), 332-3

30 (bottom left) — W.O. Stanley, 'Notices of Sepulchral Deposits with Cinerary Urns found at Porth Dafarch, in Holyhead Island, in 1848...' *Archaeological Journal* XXXIII (1876), 132-43; S. Youngs, *The Work of Angels, Masterpieces of Celtic Metalwork, 6th-9th centuries AD* (1989), 31

31 (right) — C.W. Phillips, 'The excavation of a hut group at Pant-y-saer in the parish of Llanfair-Mathafan-Eithaf, Anglesey', *Archaeologia Cambrensis* 89 (1934), 1-36; N. Edwards, *EMSW*, 99-101

32 (top left) — J. Knight, *Glamorgan County History Vol. 2* (1984), 333, fig.54; E. Campbell, *EMSW*, 85

30 (top left) — T. Dickinson, 'Fowler's type G penannular brooches reconsidered', *Medieval Archaeology* 26 (1982), 46-53; J. Knight, *Glamorgan County History Vol.2* (1984), 333-4; A. Lane, *EMSW*, 117

30 (top left) — G.C. Boon, 'Three Bones of S. Tatheus: or, duw yn anghyfiawn ni rann', *The Monmouthshire Antiquary IV* (1981-2), 2-5

32 (top right) — Dr H.S. Green, *in litt.*

32 (bottom left) — H.N. Savory, 'Some sub-Romano-British Brooches from South Wales'. In: D.B. Harden (ed), *Dark Age Britain* (1956), 49 ff., fig.11.5

32 (centre) — G.C. Boon, 'Two Celtic pins from Margam Beach, West Glamorgan', *Antiquaries Journal* 55 (1975), 400-404

33 — A.G.O. Mathias, 'South Pembrokeshire Early Settlements', *Archaeologia Cambrensis* (1927), 195, Fig.4

33 — T.C. Lethbridge, 'Excavation of a House-Site on Gateholm, Pembrokeshire', *Archaeologia Cambrensis* (1930), 366 ff., fig.6.3

33 — L. Alcock, 'Dark Age Objects of Irish Origin from the Lesser Garth Cave, Glamorgan', *Bulletin of the Board of Celtic Studies* 18 (1959), 221 ff.; E. Campbell, *EMSW*, 86-7

33 — C. Fox, 'An Irish Bronze Pin from Anglesey', *Archaeologia Cambrensis* 95 (1940), 248; for similar pins, see E.C.R. Armstrong, 'Irish Bronze Pins of the Christian Period', *Archaeologia* 72 (1921-22), 71-86

34 (left) — R. Brewer, *in litt.*

34 (bottom right) — J.M. Lewis, 'Recent Finds of Penannular Brooches from Wales', *Medieval Archaeology* 26 (1982), 151-154

34 (top right) — T.K. Penniman, 'Culver Hole Cave, Llangennith, Gower' *Bulletin of the Board of Celtic Studies* 6 (1931-3), 90-92; J.Graham-Campbell, 'Some Viking-Age Penannular Brooches from Scotland and the origins of the 'Thistle-Brooch'. In: A. O'Connor and D.V. Clarke (ed.), *'From the Stone Age to the "Forty-Five"'* (1983), 310 ff., fig.136b; J. Knight, *Glamorgan County History* Vol.2 (1984), 334, fig.54.6

35 (right) — Redrawn from F. Lynch, *Catalogue of Archaeological Material, Museum of Welsh Antiquities, University College of North Wales, Bangor* (1986)

35 (left) — G.C. Boon, *Welsh Hoards* (1986), 98-102

36 — E. Okasha, 'A New Inscription from Ramsey Island', *Archaeologia Cambrensis* 119 (1970), 68-70

39 (left) — Reproduced with permission from W. Wynn Williams, 'Leaden Coffin, Rhyddgaer', *Archaeologia Cambrensis* IX (1878), 136-140. Also in: F. Lynch, *Catalogue of Archaeological Material, Museum of Welsh Antiquities, University College of North Wales, Bangor* (1986), 87 and fig.23, 3; ECMW 27

38, 39 (right), 42 — T.A. James, 'Air Photography of Ecclesiastical Sites in South West Wales' (forthcoming)

52 (right) — D. Webley, 'The Ystrad (Breckn.) Ogam Stone, A Rediscovery', *Archaeologia Cambrensis* 106 (1957), 118-120

54, 55 — See also *Glamorgan Inventory* Vol I Part 3 (1976)

62 — H.N. Savory, 'Excavations at Dinas Emrys, Beddgelert (Caern.), 1954-56', *Archaeologia Cambrensis* 109 (1960), 61, fig.7, plate VIII (6)

65, 68 — *Glamorgan Inventory* Vol.I Part 3 (1976)

73 (bottom left) — J.M. Lewis, 'An Early Christian Stone from Pen-y-fâi, Glamorgan', *Archaeologia Cambrensis* 119 (1970), 71-74

78 (top centre) — G. Speake, *Anglo-Saxon Animal Art and its Germanic Background* (1980), Plate 8K, 58-9

78 (left) — M. Redknap, 'Monknash, South Glamorgan', *Morgannwg* 33 (1989), 71-2

78 (below centre) — W.F. Grimes, 'A Leaden Tablet of Scandinavian Origin from South Pembrokeshire', *Archaeologia Cambrensis* 85 (1930), 416-417

78 (right) — J.M. Lewis, 'Recent finds of Penannular Brooches from Wales', *Medieval Archaeology* 26 (1982), 151-154, Plate V

80 (top right) Canon Fisher, 'The Welsh Celtic Bells', *Archaeologia Cambrensis* 6 (1926), 324-334

81 (top) T.D. Kendrick and E. Senior, 'St Machan's Shrine', *Archaeologia* LXXXVI (1936), 105-118

81 (bottom) L. Butler and J. Graham-Campbell, 'A lost reliquary casket from Gwytherin, North Wales,' *Antiquaries Journal* LXX (1990); E. Lhuyd. 'Parochialia,' *Archaeologia Cambrensis* supplements, 1909-11

Selection of further reading

Welsh Early Christian Monuments

Davies, W. *Wales in the Early Middle Ages*, Leicester, 1982

Lewis, J.M. 'A survey of the Early Christian monuments of Dyfed, west of the Taf'. In: *Welsh Antiquity*. Essays presented to H.N. Savory (1976), 177-192

Macalister, R.A.S. *Corpus Inscriptionum Insularum Celticarum*, Dublin, 1945

Moore, D. Monuments of Early Christianity in Wales, *Amgueddfa* 11 (1972), 3-22

Nash-Williams, V.E. *The Early Christian Monuments of Wales*, Cardiff, 1950

Radford, C.A.R. *Margam Stones Museum*, H.M.S.O., 1949

Royal Commission on Ancient and Historic Monuments in Wales, *An Inventory of the Ancient Monuments of Glamorgan Vol. I Part III 'The Early Christian Period'* HMSO Cardiff, 1976

Seaborne, M. *Celtic Crosses of Britain and Ireland*, Shire Archaeology, 1989

Other Early Christian Monuments

Allen, J.R. *The Early Christian Monuments of Scotland*, Edinburgh, 1903

Bailey, R.N. and Cramp, R.J. *Corpus of Anglo-Saxon Stone Sculpture Vol II 'Cumberland, Westmorland and Lancashire North-of-the-Sands'*, Oxford University Press, 1988

Cramp, R.J. *Corpus of Anglo-Saxon Stone Sculpture Vol.I 'County Durham and Northumberland'*, Oxford University Press, 1984

Lang, J.T.(ed.) 'Anglo-Saxon and Viking Age Sculpture and its Context', *British Archaeological Report* 49, Oxford, 1978

Langdon, A.G. *Old Cornish Crosses*, Truro, 1896

Kermode, P.M.C. *Manx Crosses*, London, 1907

Early Christian Wales

Bromwich, R. (ed) *The Beginnings of Welsh Poetry. Studies by Sir Ifor Williams*, University of Wales Press, 1980

Davies, W. *Patterns of Power in Early Wales*, Clarendon Press, Oxford, 1990

Edwards, N. and Lane, A. *Early Medieval Settlements in Wales A.D. 400-1100*, Early Medieval Wales Research Group, Cardiff, 1988

Morris, J. *The Age of Arthur*, Phillimore, 1973

Thomas, C. *Celtic Britain*, Thames & Hudson, 1986

Metalwork

Youngs, S. (ed.) *The Work of Angels. Masterpieces of Celtic Metalwork, 6th-9th centuries A.D.* British Museum Publications, 1989

Glossary

abad (Welsh) — abbot

Anglo-Scandinavian — compound name to describe combination of Saxon (English) and Viking styles

brenin (Welsh) — word for ruler, king

burh (Old English) — fortress maintained by the population of an area (ancestor of 'borough', legally established community)

carbonised — burnt and converted to carbon

charter — document granting privileges and recognising rights

civitas capital — capital of native tribe in Roman Britain

clas (Welsh) — a form of religious community; cloister

consul (Latin) — chief Roman magistrate. Roman dates were by reference to the presiding consuls

crannog — artificial island made of brushwood, peat, logs and stone. From Irish 'crann', a tree

decurio (Latin) — elected counsellor

dendrochronology — tree-ring dating, by matching identified sequences of tree-ring widths to master chronologies

ecclesia (Latin) — church (occasionally monastery)

food-rent — rent in kind

fret-pattern — geometrical design composed of straight lines, resembling L or T-slots in a key

genealogy — pedigree, account of person's descent from an ancestor

gesso — a prepared surface of plaster as a ground

Hiberno-Norse — compound name to describe a combination of northern British and Viking styles

interlace — the drawing of 2 series of crossing threads, so that they pass alternately above and below each other

half-uncial — new style of rounded letters, established by the 7th century

knotwork — a developed form of plaitwork

llan (Welsh) — enclosure, later church

llys (Welsh) — court

maen (Welsh) — stone

maerdref (Welsh) — maer's (royal official's) town. Nucleated settlement surrounding the court

manumission — grant of release from slavery or bondage

martyrium (Latin) — martyr's memorial, often in the form of a walled enclosure around the grave

mere — lake, pond

millefiori — mosaic-patterned inlay created by fusing coloured glass rods together and drawing them out into a thin rod which can be cut into sections

minster — from vernacular Old English *Mynster*, used to denote 'mother church' or major church

motif-piece — small portable piece of scrap material, usually bone or slate, bearing discretely carved or incised patterns

orans (Latin) — standing with arms outstretched in ancient attitude of prayer

penannular — in the form of a ring, with a break at one point. Brooches in this form have a separate pin which swivels on the hoop

plaitwork — a lattice with turns at the edges, described by the number of cords

podum (Latin) — monastery

polyhedral — having many faces or sides, usually more than 6 plane faces

presbiter (Latin) — Christian official, priest (literally 'older')

quillons — cross guard of a sword

radiocarbon dating — scientific method of dating based on the measurement of the concentration or rate of decay of a radiocarbon isotope in carbon-containing samples

rex (Latin) — king

sarcophagus — stone coffin; often embellished with sculpture

scriptorium — writing room of a monastery

seax (Old English) — knife, in particular a form of iron battle-knife

Stafford-knot — type of knot-pattern

triquetra — closed-knot motif of three-lobed form

verdigris — green pigment, often made from copper acetate

villa (Latin) — a holding, farmstead, hamlet

zoomorphic — representing or imitating animal forms